A Guide to Discipline-Based Art Education

Learning in and through ART

A Guide to Discipline-Based Art Education

Learning in and through ART

S T E P H E N M A R K D O B B S

The Getty Education Institute for the Arts

The Getty Education Institute for the Arts
1200 Getty Center Drive, Suite 600
Los Angeles, California 90049-1683

10 9 8 7 6 5 4 3 2 1

Library of Congress Cataloging-in-Publication Data

Dobbs, Stephen M.
 Learning in and through art : a guide to discipline-
 based art education / Stephen Mark Dobbs.
 p. cm.
 Includes bibliographical references.
 ISBN 0-89236-494-7
 1. Art–Study and teaching–United States–
 Handbooks, manuals, etc. I. Title.
 N105.D64 1997
 707′.073–dc21 97-31849
 CIP

Contents

1 INTRODUCTION

2 THE DISCIPLINES OF ART

3 FEATURES

4 RESOURCES

5 THE FUTURE OF DBAE

Foreword

Every significantly new approach to educational practice brings with it at least two new demands. The first is the formulation and clarification of theoretical ideas that make plain the aims of the enterprise and the assumptions and values upon which it rests. The second is the identification of the new pedagogical competencies that new conceptions of the aims, content, and form of practice require. Discipline-based art education (DBAE), while not born yesterday, is, in the light of historical context, a fresh and significant approach to teaching in and through the arts. As such, it requires of those who would theorize about DBAE a clear conception of its distinctive aims and their educational justifications. It requires of teachers who wish to use DBAE an ability to design programs that, on the one hand, are appropriate for the particular students they teach and, on the other hand, are congruent with the values of DBAE itself. To help clarify theory and guide practice, it is useful to have a resource that in plain English describes the parts of which it consists and the values it seeks to attain. Stephen Dobbs and those with whom he has worked to create *Learning in and through Art: A Guide to Discipline-Based Art Education* have provided just that.

The importance of conceptual clarity, in my view, is hard to overestimate. Unless one understands the major ideas that animate DBAE, confusion and infidelity to its aims are likely. DBAE is complex and subtle. It is also ambitious. It models for teachers in American schools and elsewhere a conception of what the teaching of art can become. It embraces a set of processes that reflect some of the most important things that humans do with art: they create it, they are moved by its countenance, they understand its location and contribution to culture over time, and they argue and debate its value and significance. DBAE programs are intended to promote the competencies and forms of understanding with which the young can intelligently engage in such processes.

But DBAE is not only concerned with what some regard as the "intellectual" side of art education. Art without passion is empty of its most significant quality. DBAE is also interested in helping students experience what is passionate, what is moving, what is aesthetic not only about the arts, but about all those aspects of the world from which aesthetic experience can be secured.

The outcomes implied in the foregoing do not emerge simply as a function of maturation. Complex and subtle forms of learning need assistance from those who teach, whether that assistance comes from professionals working in schools or parents engaging

their children at home. DBAE is designed to provide not a packaged curriculum, but a conception that is open to thoughtful interpretation and appropriate modification so that it suits local circumstances. Put another way, DBAE is not a one-size-fits-all curriculum for American schools.

Because DBAE is not a curriculum, conceptual clarity about its aims, components, and their meaning is particularly important. The clarity of the book that Stephen Dobbs has prepared is the result of several years of distillation. At the same time it is not the last word. Conceptual ideas—like practices themselves—change along the way. *Learning in and through Art*, as good as it is—and it is good—should be considered an iteration, a milestone on a journey designed to yield an increasingly more adequate conception of what the arts can be in the lives of the young.

For me, among the most revealing sections of *Learning in and through Art* is the discussion regarding the features of the four disciplines. Dobbs walks a narrow and careful line between art criticism and art history and art history and aesthetics, recognizing that these categories are social constructions that are parsed perhaps too neatly in universities but that seldom emerge in such neat patterns in classrooms. Crisp borders often work well in such institutional settings as universities where professional identities are important to protect, but in the practical affairs of classroom life things are often "messy." Nevertheless, understanding, for example, two of the ways in which the term *aesthetic* can be used—as a quality of experience and as a branch of philosophy—is important, even though in a classroom context both might fly under the same flag. Yet teachers or theoreticians who conflate these two conceptions of *aesthetic* are likely to make learning difficult; conceptual confusion is no educational virtue. *Learning in and through Art* will help readers avoid it. Indeed, the entire book is an effort to clarify. Clarity is often facilitated by style in writing. Here too Stephen Dobbs's book shines.

It is reassuring that DBAE has secured the endorsement of numerous state departments of education. In fact, most states having a curriculum framework for the visual arts embrace a rationale that resembles quite closely the premises and values of DBAE: a curriculum that addresses four areas of learning, that is sequentially organized, that has relatively clear aims, that is assessable over time. At the same time, it is important to recognize that although the arts are included in national and state agendas for educational reform, the practice of arts education, like the practice of science and social studies education, needs further enhancement. For example, in the field of arts education, arts consultants are still all too rare, especially in the Midwest and western part of our nation. In many states the requirement that elementary school teachers have in their preparation

a course or two in arts education as a condition for certification does not exist, and hence elementary school teachers are often expected to teach in a subtle and complex field without the background to do so. All the more reason we need *Learning in and through Art.*

Although the needs that exist in our field are substantial, so too has been our progress. The conception of art education reflected in DBAE, in my view, is a model that can serve the educational interests not only of the arts, but of the sciences and social studies as well. It is a generous conception that lends itself to adaptation to local circumstances. It is a conception that addresses a variety of outcomes, and it is a conception that demystifies what is appropriately demystifiable about the arts. *Learning in and through Art* can serve not only those of us who care most deeply about the potential contribution of the arts to the education of the young, but those who work in other fields and who care as deeply about the realization of other educational ends. Thus, in some ways this guide is not only a guide for art educators, it is a model that can be emulated by those working in other fields. That is quite an achievement.

Elliot W. Eisner
Stanford University

Preface

Learning in and through Art is designed to introduce and provide a basic background and understanding of discipline-based art education (DBAE). A comprehensive approach to teaching and learning in art, DBAE has been established in many schools and school districts throughout the United States in grades kindergarten through 12, in higher education and lifelong learning, and for art museum audiences. This volume reflects an ongoing evolution and current developments in DBAE. It serves as an update to *The DBAE Handbook*, published in 1992 by the Getty Center for Education in the Arts, now named the Getty Education Institute for the Arts.

Learning in and through Art focuses on the basic tenets of discipline-based art education, an approach that features content drawn from four foundational art disciplines: art-making, art criticism, art history, and aesthetics. This approach was developed to provide greater substance and rigor in the teaching of art, a subject that has never enjoyed much prominence or priority in the curricula of America's schools.

To facilitate learning about DBAE through a general overview, this book offers a selective rather than an exhaustive survey of concepts, resources, and issues in discipline-based art education. It distills significant common features of DBAE for readers who may not have the time or opportunity to delve more deeply into the literature, which is abundant for those who do seek to explore DBAE in more depth (see the annotated bibliography included in this volume). *Learning in and through Art* implicitly recognizes different levels of need and interest, and strives to address the subject in a clear and concise manner, so that this publication might enjoy the widest possible use.

This book is written for diverse audiences, including art specialists and supervisors, classroom teachers, teacher educators, museum and community art educators, school principals and superintendents, and parents and school boards. All of these groups have in common the goal of seeing students learn more effectively, so that they can draw on that learning as they lead full and productive lives. DBAE can help fulfill that aspiration by providing a flexible and attainable framework within which students can create, understand, and appreciate the visual arts. A comprehensive program in art can also facilitate the integration of art with other subjects in the curriculum, and may be instrumental in helping to achieve a variety of general educational goals. This project has benefited from the combined and collective thinking, teaching, scholarship and research, experimentation,

practice, and professional efforts of literally dozens of colleagues who share a commitment to strengthening and sustaining quality art education programs for students in schools and other settings. To increase the book's user-friendliness for practitioners, the text is not interrupted by or burdened with academic or individual citations. The publications and other sources that have contributed concepts and practices are listed in detail, with annotations, following the final chapter.

Creating this volume has been a team effort. My assignment was to collect, collate, and extrapolate from a large and constantly growing literature, recognizing that all of the topics in this book deserve more extensive treatment in order to be fully developed and appreciated. The valuable input and reviews of all of the professional colleagues listed below are acknowledged with enormous thanks. Any errors of fact, interpretation, or omission are entirely my own.

Gratitude is expressed to Terry Barrett, Sheila Brown, Dennis Cannon, Vesta Daniels, Jack Davis, Gary Day, Michael Day, Jean Detlefsen, Margaret DiBlasio, Phillip Dunn, Mary Erickson, Virginia Gembica, Karen Hamblen, Edith Johnson, Phyllis Johnson, Sher Kenaston, Anne Lindsay, Jessie Lovano-Kerr, Nancy MacGregor, William McCarter, Sally McRorie, Ronald Moore, Michael Parsons, Martin Rosenberg, Nancy Roucher, Blanche Rubin, Ralph Smith, Mary Ann Stankiewicz, Mark Thistlethwaite, Brent Wilson, Joyce Wright, and Marilyn Wulliger.

I also want to express special appreciation to Leilani Lattin Duke, director of the Getty Education Institute for the Arts, for her continuing encouragement, and to the Getty staff who participated in the preparation of this book: Sabrina Motley, David Pankratz, Jeffrey Patchen, Vicki Rosenberg, Kathy Talley-Jones, and Harriet Walker.

Stephen Mark Dobbs
San Rafael, California

Introduction

1

DEFINITION

What Is Discipline-Based Art Education?

Discipline-based art education is a comprehensive approach to instruction and learning in art, developed primarily for grades K–12, but also formulated for use in adult education, lifelong learning, and art museums. It is designed to provide exposure to, experience with, and acquisition of content from several disciplines of knowledge, but especially four foundational disciplines in art—art-making, art criticism, art history, and aesthetics. Education in these disciplines contributes to the creation, understanding, and appreciation of art, artists, artistic processes, and the roles and functions of art in cultures and societies.

Each of the disciplines provides a different lens or perspective from which to view, understand, and value works of art, as well as the world in which art objects are created. In the use of the word *disciplines*, several assumptions are operating: (a) that such fields constitute recognized bodies of knowledge or content, (b) that communities of professionals study and perform in each discipline, and (c) that characteristic procedures and ways of working exist that can facilitate exploration and study.

These disciplines are sources of knowledge about and experience in art. They are domains of knowledge and skill that have been and continue to be developed by individuals (artists, art critics, art historians, and philosophers of art) who conduct inquiry within the disciplines and who make contributions to their content. These disciplines reflect what practitioners actually do and say in their work. In fact, DBAE itself promotes inquiry into the foundational art disciplines.

But art disciplines alone do not furnish the exclusive content for DBAE. Additional fields that provide related resources include anthropology, archaeology, communication, cultural studies, educational assessment, linguistics, philosophy, and sociology. Current developments in these fields increasingly help us to understand art education more fully. In this volume, however, the focus is on the four foundational art disciplines noted above. It is the disciplines of art that provide the basic knowledge, skills, and understanding that enable students to have broad and rich experiences with works of art. Students can accomplish this in at least four ways:

- *by creating works of art*, through the skillful application of both experience and ideas, with tools and techniques in various media (art-making);

3

- *by describing, interpreting, evaluating, and theorizing about works of art* for the purposes of increasing understanding and appreciation of works of art and clarifying the roles of art in society (art criticism);

- *by inquiring into the historical, social, and cultural contexts of art objects* by focusing upon aspects of time, place, tradition, functions, and styles to better understand the human condition (art history); and

- *by raising and examining questions about the nature, meaning, and value of art*, which leads to understanding about what distinguishes art from other kinds of phenomena, the issues that such differences give rise to, and the development of criteria for evaluating and judging works of art (aesthetics).

At the same time, although it is useful to define disciplines in order to grasp their principal roles and functions in encounters with works of art, these fields are also fluid, shifting, and intermingling with one another. Therefore, any closed definitions will eventually be shown to be insufficient, as the boundaries of the disciplines change and (usually) expand as related interests and new issues surface.

DBAE is a comprehensive approach to art education. DBAE programs, originally devised for but not limited to K−12 students, are based upon a rationale for art in general education. For example, works of art educate children about the world. Art helps us to understand how the many different communities of this increasingly interdependent world, both past and present, live and think and feel about their lives, their cultures, and their place in the world. In a comprehensive program, works of art provide the content for study, and teachers are encouraged to select works that will be meaningful for students. Thus no canon exists, no list of masterworks or indispensable items. The artworks studied depend on the audience in the classroom. Selected artworks need to be rich in meaning and interpretation, unique or interesting, and engaging for students.

A comprehensive approach employs specific strategies to deliver content in the classroom, such as inquiry-based experiences that engage students in making art, critical and historical investigation, and aesthetic inquiry. Talking about, writing about, and researching works of art are important strategies. For successful implementation, a comprehensive approach requires a support network of policy and administrative leadership, professional development, and a variety of curricular and community resources.

What Are DBAE's General Characteristics?

As DBAE has developed, it has acquired certain general characteristics that help to define and distinguish discipline-based art education programs from other models in art education. These features may be in place or in the process of being developed at sites throughout the nation:

- Students are engaged in the *rigorous study of art* derived from the four art disciplines.

- A long-range *program planning capacity* for art is in place, given impetus by the adoption by the local school district, university, or art museum of a policy statement and goals for student learning that include comprehensive art education.

- A *written art curriculum framework* exists, or is in the process of being developed, in which learning is sequenced within and between grades to reflect developmental and age-appropriate factors.

- Written, sequential lesson units and learning experiences engage students in balanced attention and study derived from the *content of the four foundational art disciplines:* art-making (also known as studio art or art production), art history, art criticism, and aesthetics (also known as philosophy of art).

- Art is *taught by certified teachers* who are provided opportunities for professional development to build their knowledge, skills, and understanding of DBAE. Art specialists and classroom or other subject teachers collaborate in planning and teaching.

- Students have *access to school-sponsored and community-based art experiences and resources,* such as frequent visits to art museums or to other public art settings.

- *Assessment of student learning* is conducted on a regular basis, with results reported to stakeholders, including students, teachers, administrators, policy makers, and parents.

- Art may be *integrated with the general curriculum* through application of the distinctive lenses acquired through study of the four art disciplines to content in other subject areas. Art may be integrated into other subject areas and vice versa.

- Art education is *for all students*, not just those who demonstrate talent in making art. Students with special needs are also identified and provided with art instruction at all levels. DBAE is for all students, not just those who are identified as "gifted and talented" and therefore favored with art instruction.

- The art program is appropriately *coordinated, administered, and supported at different levels:* by the faculty leader and principal within the school, and by the curriculum supervisor within the school district. The superintendent may assume responsibility for advocating and explaining the program to the school board, which in turn can support the program with parents and the community.

- *Technology is used to broaden art teaching and learning options.* Teachers and students have access to and use technology (a) to enhance production, creation, and/or design of works of art; (b) to communicate about art; and (c) to access and manage information about art.

What Is *Not* DBAE? It may also be useful to list briefly some descriptions of what discipline-based art education is *not*:

- It is not a curriculum in the sense of being a stipulated series of learnings arranged in a prescribed manner. Rather, it is a conceptual framework or set of principles and an approach to teaching and learning in art based upon disciplines that contribute to the making and understanding of art.

- It is not a promotion of any one of the art disciplines over the others. Rather, it entails balanced attention (not necessarily equal or pro rata time for each of the art disciplines) to all of the foundational disciplines over a given period of time.

- It is not a monolithic system with a single conception of art, uniform notions

of content, or a common prescribed set of practices. Rather, it is an evolving approach, one that is host to many variations of philosophy and practice within the basic commitment to comprehensive treatment.

- It is not intended for schools or other settings with identical specifications. Rather, it is flexibly configured to fit the needs and circumstances of local instructional goals, curriculum, and resources.

- It is not a single lesson. Rather, it is best presented as a unit of study taught over time, where each of the four discipline perspectives are covered in learning about works of art.

- It is not based on a conception of students as prospective scholars, artists, or discipline specialists. Rather, it is dedicated to meeting the needs of young persons and others for a general understanding of art as a basic form of human culture and as a basic means of human communication.

The DBAE disciplines are a means to an end—teaching kids about art.

NEEDS ADDRESSED BY DBAE

How Are the Goals of General Education Met? In previous eras the neglect of reading, writing, and discussion skills as part of the art lesson contributed to a widespread perception among many school administrators, teachers, and parents that art did not contribute to general goals of schooling, such as teaching students how to think and learn to be problem solvers. Worse, the art lesson was often seen as outside the pale of the curriculum that mattered, a nonacademic activity in which no real "learning" took place, or at least none worth serious assessment.

The art lesson provided relief from the pressure of the academic curriculum; it was "tenderhearted" rather than "hardheaded," dealing with emotions and affect, which were considered extraneous to the real purposes of schooling. Art appeared to give

students the opportunity to relax and not have to use their minds. Everyone (including students) knew that individuals were not promoted or graduated from school based upon their performance in classroom art activities.

By contrast, in DBAE the art lesson strongly supports general educational goals of the school, such as the goal of cognitive development. Students in art are challenged perceptually and intellectually as they learn a body of knowledge (art). They are encouraged to draw on their own ideas and feelings, their experience in the world, and the works of artists other than those presented in the classroom in order to know, understand, and create complex objects called works of art.

Such an approach nurtures student creativity, but does so while developing competence in perception, communication, imagination, judgment, and social understanding. The study of art is also a tool for developing problem-solving and higher-order thinking skills, and for the acquisition and exploration of language and the development of visual literacy. School board credos and public opinion strongly endorse the basic mission of schools as teaching students to think, to become problem solvers, to develop their minds.

The DBAE approach also values flexibility and diversity in choice of curriculum content, selection of instructional resources, and respect for different student backgrounds. It taps different learning styles and is consistent with the maxim that there are many different ways of knowing and ways of learning. This includes forging successful study and work habits in both school and society. The art lesson alone cannot accomplish this, but together with other kinds of educational experiences, art can do much to help students function in a culture that is heavily dependent upon and dominated by visual forms of experience. In fact, the DBAE art lesson likely provides the very best (if not the only) place in the program of most schools where students have the opportunity to acquire the visual literacy that will empower them to function successfully in a visually saturated society. DBAE also acknowledges the contributions of art education to the behavioral and psychological well-being of students, nurturing such traits as self-esteem, patience, and rigor.

Practitioners function in domains that are richly intellectual, featuring such cognitive operations as perception, analysis, interpretation, and judgment. Skills of observation and problem solving are directly cultivated in the DBAE unit of study. The exercise of such higher-order thinking in art, as John Dewey observed more than 60 years ago, is as profoundly "intellectual" as the act of solving a quadratic equation. Such cognition is as familiar and commonplace to practitioners of DBAE as it is to practitioners of mathematics and other academic disciplines.

The theories of multiple forms of understanding and intelligence, explained by Howard Gardner and cognitive scientists, describe many different but related domains of mental functioning, revealing that artistic engagement is a mind-building experience. The concept of the "intelligent eye" also contemplates extensive mental functioning in the exercise of art, especially in looking at and thinking about images. This is contrary to the belief that art has little intellectual content and is primarily about feelings. There are methods, moreover, teachable in schools, through which students can learn to see and understand the content in works of art that had been invisible to the untrained eye. David Perkins calls this making the invisible visible.

How Are the Goals of Art Education Met?

The goals of art education have been debated in the professional field for decades. Two general views may be outlined. One holds that art is a source of knowledge, beliefs, and values about ourselves and about our world, and that these are a critical and necessary part of the education of a citizen. Art offers access to knowledge, insights, and types of meaning that are not available elsewhere in the curriculum of most schools. For example, visual culture (paintings, drawings, sculptures, architecture, film, and so on) carries expressive content that can be learned, enjoyed, and utilized. Therefore, art should exist in the curriculum for what it provides, not for its subordinate or contributory purpose in advancing nonart kinds of knowledge. This is the *essentialist* argument (also called the noninstrumentalist or intrinsic-value argument), which holds that art provides a unique learning experience that is best addressed through a quality art education program.

The other view, which does not exclude the essentialist view, emphasizes the contributions that art makes to attainment and success in other subject areas and to more general goals of schooling. For a long time, the rationale for art in the curriculum was that it provided an outlet for children's feelings and "creative expression" that were not accommodated in the academic program.

Another rationale for art education is that the study of art promotes attention to perception and expression, and thus contributes to the building of language and communication, critical thinking, and problem-solving skills. If the policies of the local school board include the development of imagination or of awareness of a multicultural society, art might be enlisted in the service of these student outcomes as well. This is the *instru-*

mentalist (or utilitarian or extrinsic-value) conception of art's role in general education. It has often had to suffice because of the narrow chance that a school board or principal would appreciate or accept the essentialist rationale.

Both the essentialist and instrumentalist views have legitimacy for art education. On one hand, art education ought to merit its place in school programs because of what it uniquely and specifically provides for students. Art offers access to languages, experiences, and meanings that are understood and conveyed idiosyncratically through the expression and shaping of visual form. At the same time, no opportunity should be missed to embrace the collateral learnings and auxiliary educational payoffs that are a part of students' experience with art. Therefore, one routinely witnesses in DBAE classrooms exercises in perception, interpretation, and judgment based upon works of art that stimulate inquiry learning and lead to written and spoken language development. Essentialist and instrumentalist views alike are represented in a comprehensive approach to art. It is not one or the other. Art is important both for the distinctive and unique contributions it makes to learning and for the ways in which it serves general goals of schooling. This is manifest in the widespread activity over recent decades of setting goals for the field of art education that serve both views.

Goals for the field of art education are set at various levels: by national panels and commissions (such as those that developed the national standards, discussed below), by state framework committees, by teacher education institutions and theorists in the field, by professional organizations of art educators, and by practitioners. For example, the National Art Education Association has promulgated, in its "Quality Goals Statement" (1982), a conception of art and learners that broadly defines art education but clearly endorses a comprehensive approach. DBAE helps meet both essentialist and instrumentalist goals for art education.

How Are Societal Goals Met? The United States

is now the world's most multicultural society, and our culture is rapidly transforming itself. Demographic changes in U.S. classrooms have been accelerating throughout the past 10 years. DBAE supports the larger goal of creating a society in which there is opportunity and fulfillment for all citizens. It does this by providing a receptive and welcome place for cultural diversity in the school program. Indeed, works of art are one of the primary indicators of a nation's, culture's, or historical epoch's values, achievements, social

structure, and faith traditions. By using a wide variety of exemplars of works of art from world cultures, educators can introduce students to the richness of cultural diversity. An increasing number of museums are seeking to attract more culturally diverse audiences by building collections and installing exhibitions of world art.

Schools now face the complex task of addressing the educational needs of an increasingly diverse population of millions of young people. America's classrooms routinely feature an array of racial, ethnic, national, linguistic, and cultural differences and traditions. The concept of the "melting pot" (all cultures blended into a single American culture) has been superseded by the metaphor of the "tossed salad" or "stew" (all cultures retaining some autonomy and legitimacy even while contributing to a common American culture). Assimilation into the American cultural mainstream is complicated by the debate over exactly what that mainstream culture may be. When this situation is prevalent in thousands of schools, pluralism translates into many new and provocative questions about the curriculum.

Studying the art of many cultures helps students to understand the people of those cultures, not just their artifacts. For example, the study of Chinese scroll paintings of the Sung Dynasty (960–1279 AD) reveals a reverence for nature in the form of meticulously drawn landscapes featuring magic mountains, lakes, and gardens. Scholars might unwrap a portion of such a scroll and discuss the meanings in that landscape. After viewing the work, they might actually take a walk in a garden to give texture and authenticity to their conversation and their experience. Thus studying the art of a distant time and place can help students understand and appreciate the people of such a culture and what was important to them, as disclosed by their art.

In fact, cultural diversity has helped to expand the range of curricular opportunities in art. The previous focus in the art disciplines on a primarily Western or Eurocentric tradition has shifted to global possibilities. The larger world stage provides educators with multiple occasions to introduce considerations and characteristics of culture that broadly affect what students are experiencing and learning in the four foundational art disciplines. This, in turn, supports the societal goal of building understanding and appreciation for the diverse communities that make up the United States.

Discipline-based art education welcomes and capitalizes upon these developments. The approach represents an emancipation, wherever possible, from the old boundaries of cultural thinking about sources for artists, works of art, and artistic traditions. For example, aesthetics offers a fertile context for understanding and appreciating multiculturalism. By

examining the purposes and philosophies of art in various societies, students can begin to see the rich mosaic of the world from many perspectives.

Until recent times, an overwhelming emphasis on Western, and particularly European, art has been almost universal in school art programs, from kindergarten through college. But now there is recognition that other cultures, such as those of Asia, Africa, and South America, have been neglected as sources of rich imagery and ideas that can help students create, understand, and appreciate works of art. Therefore, a DBAE program might include exemplars of art and a range of types of art (such as folk art) from African, Asian, European, and Latin American cultures alike, ranging from the most ancient to the most contemporary. The eventual impact of such experiences on students in schools will play itself out in the larger society of which students are members.

THE POLICY CONTEXT

What Opportunities Does Education Reform Provide?

The 1980s and 1990s, like the decades before them, featured continuing efforts at education reform and restructuring in America's schools. The most recent wave began in 1983 with the widely disseminated report *A Nation at Risk*, which painted an alarming picture of a United States whose schools were in trouble and whose students were falling behind in world competition.

While the challenges of reform and restructuring were being addressed in general education, an introspective eye was turned as well upon individual subject areas. Many arts educators had been stimulated by a national report published in 1977, *Coming to Our Senses: The Significance of the Arts for American Education*. This report offered 15 recommendations based upon such ambitious claims as the following: "The fundamental goals of American education can be realized only when the arts become central to the individual's learning experience, in or out of school and at every stage of life." This was followed a decade later by *Toward Civilization: A Report on Arts Education* (1988), a statement of the National Endowment for the Arts, which described such goals for art in general education as providing access to significant achievements of civilizations, fostering creativity, promoting the acquisition of effective communication skills, and helping students learn how to make choices based upon critical assessment.

Other influential advocates for moving art from the margins of school life to a more central role in general education include such organizations as the National Parent-Teacher Association, National Association of Chief State School Officers, and the College Board and Educational Testing Service. For example, the College Board includes the arts among its basic goals of schooling in its famous "green book" and "red book" publications.

The momentum of educational reform has even reached the highest political levels, with both the president of the United States and the U.S. Congress adopting the recommendations of national commissions organized to address challenges and opportunities in the nation's schools. The impact on art education has been felt in the creation of goals and standards in art for subject matter, teacher training, and assessment consistent across the states.

The "Goals 2000: Educate America Act," developed during President Clinton's administration, is a mandate for educational reform that includes the arts. Through this legislation, art education was written into federal law, acknowledging that art is a core subject, along with English, mathematics, history, civics and government, geography, science, and foreign language.

DBAE has emerged and developed in this climate of education reform. It offers an approach consistent with efforts to build substance, rigor, and success into American education. It helps meet the aspirations of many art educators for a philosophy that can successfully fulfill the ambitions the profession has always had for art in schools.

What Is the Effect of National Standards?

One of the tangible outcomes of education reform that has potential impact on DBAE has been the publication of *National Standards for Arts Education: What Every Young American Should Know and Be Able to Do in the Arts*, which was presented to Secretary of Education Richard Riley in 1994. The voluntary standards set up in this volume furnish for educators, policy makers, and the general public the philosophical and educational platform on which frameworks and curriculum guidelines in school districts are to be based, a common starting point for improving arts education in the nation's schools. The concept of national voluntary standards is based on the belief that there ought to be clear statements spelling out what every young American should know and be able to do in each subject area.

Such aspirations are not new, but the influence of DBAE in the formation of the national standards has been pronounced. The standards movement has created across-the-board national statements, so that art education in Maine, for example, will not be substantially or qualitatively different (even allowing for some regional variation) from that provided in Arizona. This takes into account the fact that varying interpretations or preferences in approach can often make DBAE programs located in the same community different from one another.

The expectation in setting up national standards is that through the provision of guidance through a broad framework, all students will have very similar educational experiences and acquire basic concepts, understandings, and skills regardless of where they are educated. Underlying this is the premise that all students are entitled to a high-quality education in every subject area.

The national standards represent a consensus among arts educators that is paralleled in the goal statements for DBAE. For example, the standards include areas of competence that can be recognized as part of DBAE, such as developing proficiency in one of the visual arts, presenting basic analyses of artworks, and demonstrating an informed acquaintance with exemplary works of art from a variety of cultures and historical periods.

The introduction to the national standards document is worth quoting in part for its broad and holistic rationale for the significance of the arts in education:

The arts have been part of us from the very beginning. All peoples, everywhere, have an abiding need for meaning—to connect time and space, experience and event, body and spirit, intellect and emotion. People create art to make these connections, to express the otherwise inexpressible.

The arts are one of humanity's deepest rivers of continuity. They connect each new generation to those who have gone before, equipping the newcomers in their own pursuit of the abiding questions: Who am I? What must I do? Where am I going? The arts are everywhere in our lives, adding depth and dimension to the environment we live in, shaping our experience daily. The arts are a powerful economic force as well. We could not live without the arts—nor would we want to.

Indeed, we depend on the arts to help us realize the fullness of our humanity. We believe knowing and practicing them is fundamental to the healthy development of our children's minds and spirits. The arts are inseparable from the very meaning of the term "education." We know from long experience that no one can claim to be truly educated who lacks basic knowledge and skills in the arts.

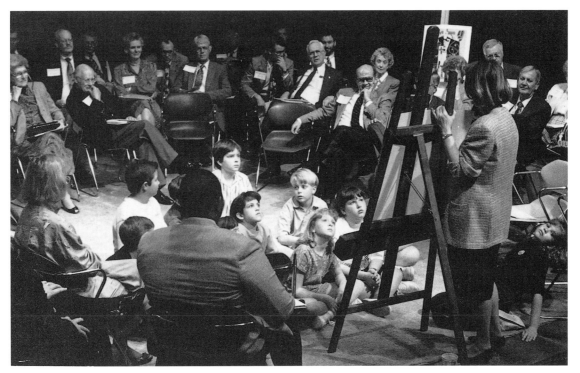

Successful art education programs form partnerships with the broadest possible spectrum of stake-holders in art education, including schools and school districts, government and civic organizations, parent groups, and school boards and legislative policy makers.

What Is the Influence of State Frameworks?

The Constitution of the United States reserves to the states the power of determining the forms of public education (Article X). Thus the states and local districts, not the federal government, actually decide what is to be taught in classrooms in every subject area. State curriculum frameworks are developed by state departments of education to provide guidance for local and regional school boards, which set policy that is intended to shape classroom practice down the line.

These state frameworks have played a significant role in the evolution of discipline-based art education by emphasizing a comprehensive, multifaceted approach to art. In turn, DBAE has directly influenced changes in many state frameworks. Although the approaches endorsed go by various names (not necessarily discipline-based art education), they have much in common with DBAE and are often conceptually identified with it.

By the 1980s, most states were reviewing and revising both their subject-matter frameworks, which provide parameters and recommend content for school districts in adopting curricular policy, and their high school graduation requirements. In both of these areas, the arts have made significant advances in recent decades, evident in more sophisti-

cated and integrated curricular frameworks for art and the adoption in many states of modest graduation requirements in art. These frameworks are typically created through extensive dialogue involving stakeholder individuals and groups (such as teachers and curriculum supervisors), who share their professional ideas, values, and experience. Through this process, a consensus is hammered out that reflects art educators' interests and expectations.

State frameworks not only provide recommendations from the state departments of education, they also carry the imprimatur of state superintendents and boards of education. They communicate to every school district within the state that certain standards ought to be met for art instruction in every school's curriculum. The recent revision of frameworks in many states demonstrates grassroots support among art specialists, curriculum supervisors, teacher educators, and art education theorists and researchers for improving the quality of programs in art through the determination of broad general policy that is essentially discipline based. For example, the California Department of Education first published its *Visual and Performing Arts Framework for California Public Schools* in 1972, before the emergence of the DBAE movement, and outlined instruction through a comprehensive approach organized around four cornerstones: artistic perception, creative expression, historical and cultural context, and aesthetic valuing. These relate directly to the disciplines of criticism, art-making, history, and aesthetics. In the 1996 version, almost a quarter century later, as well as in the frameworks of Ohio, Pennsylvania, and other states, the commitment to comprehensive art is further codified. Contributors to many of the newer state frameworks are in fact leading theorists, practitioners, and teacher educators in DBAE.

HISTORICAL EVOLUTION

What Early Rationales Influenced Art Education?

The term *discipline-based art education* first appeared in the nomenclature of the field in 1984, in an article by Dwaine Greer. Although the concept of a comprehensive, inquiry-based, and discipline-oriented approach to art education was not an entirely new idea, only in recent decades has DBAE become a paradigm for teacher training, curriculum development, instruction, learning, and assessment in art in America's schools.

A comprehensive approach to art education is markedly different from the approach taken in most U.S. schools for most of the twentieth century. Teachers who taught more than the minimum art expectations in the K–12 grades more or less had to develop teaching repertoires on their own, without the staff development, curriculum resources, and support networks that are fundamental to DBAE. For most art teachers, and for elementary classroom teachers, who often carry the responsibility for teaching art, training has traditionally been limited, resources scarce, and political support from school administrators and community benign. Most of all, rationales for art in schools followed the predictable path of utilitarian necessity, from the time of the first appearance of art in the school curriculum. For example, in the nineteenth century the evolution of the American work ethic placed a premium on drawing skills, whether for the purpose of acquiring job skills to work in a factory, to sketch portraits, or simply to encourage good penmanship and "hand-eye coordination." For decades, the early art curriculum (originally called freehand drawing) mirrored such objectives, leading to tedious acres of student drawing exercises.

By the turn of the century, however, other themes had joined "drawing development" as rationales for art education. These included "picture study," in which reproductions of paintings and sculptures (typically very histrionic or sentimental works) were coordinated with language texts to teach about moral values and socially productive behavior. Another rationale was "manual arts" study, which led to the practice of having students make practical and useful objects. Still, the dominant art-related activities in school classrooms were the drawing exercises promoted by early art educators such as Walter Smith, who had established the first professional training academy for art educators in Massachusetts in the 1870s. For a very long time, art study was almost entirely equated with the making of art.

But change was afoot. In the late nineteenth century, the child study movement, a facet of the emerging science of psychology and human behavior, kindled an interest in children's drawings and what they might reveal about mental and emotional growth. This heralded the valuing of art as a source of personal and creative expression for students, an opportunity in the school day for students to cultivate and communicate feelings and personal characteristics.

Art educators claimed that their subject would help shape young people's character and personalities even as the academic curriculum shaped their minds. Franz Cizek and others also lauded art as a source and product of play and creativity in children's lives. The psychological study of students, advanced by theory and empirical studies in the late

1800s, provided a major platform for the development of art education in the schools of the new century.

By the 1920s and 1930s, the influence of John Dewey and the Progressive Era was manifest in art education in an increasing emphasis on creativity and play as developmental tools. The child's own artwork was viewed as a special opportunity for idiosyncrasy in a school culture dominated by rules in every other subject area. A romantic mystique emerged about the "child artist," who saw and represented the world with an innocent and personal vision.

But art education retained its practical side as well. Arthur Wesley Dow at Columbia University and other teachers championed the principles and elements of design (i.e., studying art by focusing on its compositional components, such as line, color, and shape) beginning early in the twentieth century. These had been important for the industrial crafts and manual arts approaches, but they were now employed to help students appreciate works of art and the built environment.

By the 1940s and 1950s, textbook writers featured "art in daily life" themes, such as art for good citizenship and art in industrial design. These orientations of art toward serving personal and social goals appealed to teachers, but may have contributed little to expanding children's artistic skills or horizons. However, the focus on "creative self-expression" and art in service of personality development, led by the psychologist and art educator Viktor Lowenfeld, continued to be influential into the last third of the century.

Art reached the zenith of its rhetorical aspirations during World War II, when the British scholar Herbert Read, believing that art transcended issues of nationalism and politics, promoted the international refrain, "Education for art is education for peace."

Unfortunately, the minimal instructional time usually available for art in most classrooms, especially as students moved into the upper elementary grades, made it difficult for educators to develop substantive content in their art lessons. Often the art learning experience was devoted to holiday-based crafts activities and to decorating bulletin boards in school corridors with "look-alike" student projects. These were predictable activities, especially for younger children, but they unfortunately did not promote much learning about art and tended to reinforce the perceptions of teachers, school administrators, and parents that nothing really significant was happening in the art lesson, and therefore art could not be thought of as a basic subject for schooling.

Thus teachers often reflected in their training (or lack of it) and their teaching a view of art that cherished art-making to the exclusion of other dimensions of the art

experience. The "child as artist" theme emphasized bringing students in contact with studio techniques and materials in the service of creativity and self-expression. When taught by trained art teachers, the elements and principles of design were also often incorporated as standard fixtures of the studio art orientation.

Opportunities were missed to provide students with a larger conception of art and its multiple features, meanings, and richness in their own experience and in the larger world. In fact, the creativity that is justifiably admired in children's art does not emerge from a vacuum. Rather, art-making skills and competence develop from study and practice. These happen best in a learning environment that furnishes opportunities for students to learn about art through the lenses of the four disciplines.

What Were the Precursors?

In the 1960s, the reform spirit of the New Frontier and the Great Society had its counterpart in American schools. One of the most influential viewpoints was Jerome Bruner's curriculum focus on understanding, problem solving, and the fundamental structures of subjects (rather than on only learning facts about them). The sources of such knowledge were the professional practitioners of the subjects.

Bruner's approach was introduced into art education by Manuel Barkan at Ohio State University. Barkan's ideas were discussed at a seminal conference held at Pennsylvania State University in 1965, highlighting an approach calling for K–12 students to be exposed to a wide range of learning activities in art. Following the Brunerian model, Barkan claimed this would make students' experience more like that of artists and other art-related persons. The curriculum needed to reflect the content and inquiry processes not only of the artist, but also of the art critic and the art historian, each of whom provides special knowledge and insight important and useful for the creation and understanding of art.

At about the same time (1966), Ralph Smith was calling for a synthesis of child-centered and discipline-centered conceptions of art education, reprinting essays on artistic creation, aesthetics, art history, and art criticism, and establishing the *Journal of Aesthetic Education*, the editorial policy of which encourages a comprehensive view of arts education. During this same period, researchers were investigating a broad range of issues associated with student perception, responses to works of art, talk about art, cross-cultural differences, and other topics with consequences for curriculum and instruction. This

broader horizon of empirical study, represented by such figures as Kenneth Beittel, Laura Chapman, Ken Lansing, June McFee, and Brent Wilson, suggested that the development of visual perception and visual language plays a critical role in mental functioning.

The psychologist Rudolf Arnheim addressed the contributions of art to "visual thinking." Emphasis on the psychological importance of art, and especially its association with affect and emotions, had become a venerable tradition in art education. The new emphasis on cognitive growth opened art education to the possibility of contributing as well to the evolution of mind. At the same time, many art educators were concerned about the emotive and affective aspects of art being lost in favor of its conceptual ones should art education become too academic or intellectual. In fact, art educators sought to avoid separating knowing from feeling.

The focus on cognition in art was also consistent with the humanistic notion of children's developing to their fullest potential. For children who were designated "culturally disadvantaged," art was perceived to offer access to forms of communication and understanding that were insufficiently addressed elsewhere in the school curriculum. Some federal dollars available during the Johnson and Nixon years supported art-related programs in inner-city schools, in Job Corps settings, and in projects promoting cultural diversity.

A handful of model programs also promoted more experimental approaches, such as the Kettering Project at Stanford University, led by Elliot Eisner from 1968 to 1970. The Kettering elementary art program featured foundational art "domains" (production, criticism, and history) as the source of content. It also emphasized the use of a written curriculum, art reproductions, field trips to museums, and systematic evaluation.

Another significant development was the creation of federally funded educational research and development initiatives such as the Aesthetic Education Curriculum Program at the Central Midwestern Regional Educational Laboratory (CEMREL) near St. Louis and the Elementary Art Program at the Southwest Regional Laboratory (SWRL) in Los Angeles. Materials were devised for students and staff development practices were formulated for teachers to facilitate learning about critical and historical concepts in art. These programs, such as the Aesthetic Eye Project, extended practice in art education toward new ways of knowing about art in addition to those provided by the studio experience.

At the same time, the National Endowment for the Arts, with characteristically limited financial resources, featured a relatively narrow program spectrum for art education. The NEA devoted itself almost exclusively to funding artist residencies in schools.

State and local community art councils reinforced the studio orientation by supporting few alternatives to these programs.

However, by the 1980s the revision of decades-old state curriculum frameworks and guidelines gave more impetus to a comprehensive approach. The leadership of a new generation of art education professionals committed to demarginalizing the role of art in schools set forth a more ambitious vision of what children ought to experience in art. For example, the SWRL program identified at least six levels of instruction for the elementary grades, including content and visual resources that focused on art-making, art history, and art criticism. Professional sanction for the trend was represented in the National Art Education Association's "Quality Goals Statement," which endorsed a comprehensive approach to art that would require many modifications in conceptions of art and of learners, curricular goals, teacher training, instructional resources, budgeting, and other aspects of teaching and learning in art.

Finally, commercial publishers began to respond to the requirements of comprehensive art education, which included diverse knowledge of the art disciplines. Textbooks, kits, and a wide array of instructional materials began to incorporate elements of the approach. These products often featured sequenced lessons containing art-making and some critical and historical inquiry activities. They also included reproductions of works of art, in poster, slide, or video format, that provided teachers with instructional resources largely absent from most classrooms. However, although these commercial products offered some support for comprehensive art teaching, none met all of the needs of either art specialists or general classroom instructors.

How Has DBAE Developed in the 1980s and 1990s?

A new institutional resource for art education surfaced in the early 1980s. The Getty Center for Education in the Arts, now called the Getty Education Institute for the Arts, an operating program of the J. Paul Getty Trust in Southern California, was committed to supporting a comprehensive approach to art prefigured by such early writers as Bruner and Barkan. The center had formulated subject matter as substantive content derived from the art disciplines and the activities of persons who practice in those fields.

The Getty Center outlined its views in a widely disseminated publication titled

Beyond Creating: The Place for Art in America's Schools (1984), which was based upon a report of the RAND Corporation made after an investigation of art education practices in several U.S. communities. *Beyond Creating* reinforced the concept of discipline-oriented art curricula that had been proposed since the 1960s. A later monograph on discipline-based art education by Gilbert Clark, Michael Day, and Dwaine Greer provided an initial platform for the comprehensive approach.

The first implementation of DBAE took place in 1983, when the Getty Center established a Los Angeles-based research and development project in professional development and curriculum implementation. The Los Angeles Institute for Educators on the Visual Arts provided two- and three-week summer institutes designed to provide content-rich art education instruction for elementary classroom teachers. Most of these teachers had little or no professional preparation for teaching art. At the time, the numbers of art specialists in California schools had been decimated by budget cutbacks and reorganizations. In most elementary schools only generalist classroom teachers stood between students and no art education at all.

The basic strategy of the Getty Center and now the Getty Education Institute for the Arts has been to form partnerships with the broadest possible spectrum of stakeholders in art education: schools and school districts, teachers and their professional organizations, teacher training institutions, theorists and researchers, government and civic organizations, art guilds and associations, state departments of education, the commercial and manufacturing sector, parent organizations, school boards and legislative policy makers, and other foundations and funders. A central tenet in the outreach to these potential cohorts is the Getty Education Institute's emphasis on the contributions of art and its role in general education, a theme endorsed and developed by such policy makers as the late Ernest Boyer of the Carnegie Endowment and former Secretary of Education William Bennett.

Some of the ideas basic to DBAE had been brewing for more than two decades, but for the first time they occupied center stage in the field. Growing interest was also revealed by an increasing number of published research studies and in theses and dissertations focusing on aspects of comprehensive art. DBAE represented a paradigm shift to a more substantive and rigorous, content-filled, and meaningful approach to teaching art in schools.

An increasing number of presentations and debates centered on DBAE took place at the meetings of the National Art Education Association and state art education organizations throughout the second half of the 1980s and into the 1990s. The approach was

congruent with the growing climate of educational reform, which mandated more substantive educational experiences for students and the development of their higher-order cognitive skills.

Yet resistance was also evident among some art educators who had various concerns, such as the belief that a focus on disciplines would make art too much like other academic subjects, at the expense of art's singularity. Some art specialists worried that DBAE might not provide a sufficient role for creativity and self-expression, and that introduction of content from the nonstudio disciplines (aesthetics in particular) was premature, at least for grade school children. Opponents claimed that DBAE would "intellectualize" art education and that students would spend all the scarce class hours available for art talking and writing about it instead of producing it.

Exchanges were often sharp, and, in general, the field of art education was stimulated by the flow of ideas and viewpoints. The Getty Education Institute continued to play a leadership role by sponsoring meetings, supporting a vigorous publications program, and supporting demonstration and model projects. Over time, other voices in the field joined in, including those of individual theoreticians and textbook writers, teacher trainers in colleges and universities, state department of education curriculum supervisors, and commercial publishers and educational materials manufacturers.

The effort to sustain a discipline-based approach was further supported by the movement to create national standards for art education. As professional panels struggled through the early 1990s with the question of what ought to be taught at various grade levels, there was a realization that a certain line had been breached and the field could never go back. The effort to develop standards created an expectation of accountability and progress that was hard-won and would not be abandoned.

The comprehensive or multifaceted approach, in which students experience and learn about art through multiple perspectives, has established itself in the consciousness, words, and actions of the field's professional leadership. It exists across the United States on the agendas of thousands of teachers, administrators, school board members, and other persons concerned about art education. After little more than a decade since its introduction, the approach now enjoys wide acceptance in art education. Under the banner of DBAE, many others, outside the field of art education but related to it, have been introduced for the first time to substance and consequence in school art programs.

2

The Disciplines of Art

What Is the Role of Art-Making?

Art-making may be described as the process of responding to observations, ideas, feelings, and other experiences by creating works of art through the skillful, thoughtful, and imaginative application of tools and techniques to various media. The artistic objects that result are the products of encounters between artists and their intentions, their concepts and attitudes, their cultural and social circumstances, and the materials or media in which they choose to work.

The artist's purpose in engaging with a medium may be to express or interpret experience, to communicate ideas or contribute to knowledge, to explore the unknown, to produce an aesthetic response, to make money, or to persuade or manipulate. The purposes of art-making are limited only by the imagination of the maker, the materials available, a patron's or sponsor's interests, government regulations, community standards, and so on.

In DBAE, artistic creation may be selected for introductory activities, but it need not necessarily come first among the disciplines. It is possible to approach the activities of art criticism, for example, without having fashioned works of art. There is no hierarchy by which any of the foundational disciplines is valued or sequenced above the others, so nothing should be inferred from their order of discussion here. Art-making is the source of the public expression of form, energy, and idea represented by the transition from artistic intention to artistic achievement.

The process of art-making has sometimes been viewed by many art educators, as well as by the general public, as something mysterious and hard to define, a welling up from within the artist of thoughts and feelings that find tangible life in visual forms that have been shaped and worked to express those thoughts and feelings. The high value placed on the work of children and student artists is rooted in this basic respect for the complexity and highly personal aspect of art-making, one that eschews any explanation of artistic creativity that does not honor the role of unique inspiration.

But if art-making is reduced to inspiration, what can we say about it? It is challenging to map out the pedagogy that will teach, recognize, and monitor the steps and stages of inspiration. In fact, we need to understand the artistic process more fully, and not put borders around it. Some would say that efforts to examine and reflect on the

artistic process are inimical to the sense of wonder, magic, and mystery that has been traditionally associated with creating art.

Of course, to those who use written and verbal language, such as art critics, art historians, aestheticians, and sometimes artists themselves, meaning is not construed as a choice between words and images. It is both. Each form of communication is capable of eliciting meaning in its own peculiar fashion. Words may help us explain some aspects of what is happening in a painting, but there may well be another level of communication in which the painting itself directly "speaks" to those who know how to "hear" it.

One's view of art-making depends upon one's conception of art. For example, if the function of art is to awaken, strengthen, and preserve a sense of life and its potentialities, then the artist's purpose and process can be viewed as one in which he or she challenges our perception and helps us to see, think, and feel. The artist demonstrates what does not otherwise explicitly confront our senses and our consciousness. Therefore, art-making focuses upon the ways in which imagery can be produced that strikes our perception and affects our ideas, values, and feelings.

The concept of art as the revelation of the artist's idea, of what the artist knows about him- or herself and society, is a classic position in a vast literature by artists and others about the art-making process. Numerous artists have looked within themselves and described how artistic creating and making is a function of this translation, how the blank potentiality of a medium is realized through the efforts and actions of the artist to "say something," provide a "message," or make new meaning.

In the Western tradition, rooted in concepts of art as ancient as Greek philosophy, art-making is the imposition of form upon matter. The artist begins with an idea and expresses it in a medium through skill and mastery of technique. A sequence of stages or steps is implied: art begins in the mind and imagination of the artist. The application of technique is an intermediate step between the initial appearance of the form in the consciousness of the artist and the final production of a work of art.

How Do the Other Art Disciplines Integrate with Art-Making?

In Western art history, Joshua Reynolds's formal discourses to his students at the Royal Academy, Vincent Van Gogh's letters to his brother Theo, and Paul Klee's *Pedagogical Sketchbooks* are all instances of painters articulating the artistic process. Each of these artists set

down in writing his reflections and ideas about the imagery he had created. This offers insight into the kinds of knowledge explored and expressed by the maker of art. The shaping of form with aesthetic character is the public fulfillment and sharing of that knowledge. The Chinese artist Kuo-Jo-hus also has left us views on the artistic process that help viewers understand the mind of the art-maker in a non-Western tradition.

What are the significant artistic decisions and acts that explain the art-making process? What considerations are at the heart of the process? Why are some options and avenues cast aside in favor of others? How do mind and hand work together? What qualities or traits in the artist facilitate successful imposition of form upon matter? How does an artist know when a work is finished or when it should be abandoned and started over?

We have many suggestions from artists themselves, as well as thoughts offered by critics, historians, and aestheticians who have thought about the art-making phenomenon. DBAE recognizes that inquiry in each of the disciplines arises out of the others, because all are interdependent and overlapping. Although the focus of a lesson may be drawn from any one of the four art disciplines, there are opportunities prevalent throughout the classroom experience for relating and integrating the disciplines. For example, the art critic needs to understand the historic springs from which artistic ideas flow in the lives of artists in order to help us appreciate the deeply embedded physical and cultural responses that imagery elicits. Among other things, art historians seek clues to the evolution of style by exploring and documenting artists' interactions with the work of other artists, a key source of ideas for art-making in recent Western culture.

Some artists, folk artists or individuals who have yet to be "discovered" as artists, may work without exposure to or without being influenced by other artists or artistic traditions. Art-making may in fact evolve in traditional societies that have little or no contact with outsiders. Art historians research and write about such groups. Finally, the aesthetician may see in the artist's choice of tools, techniques, or responses to the medium a reflection or declaration about the nature of art.

What Issues Can Students Explore in Art-Making?

The wealth of knowledge about the art-making process is accessed in the DBAE classroom through the raising of questions and reflection upon them while students are engaged in the making, production, or studio processes. It

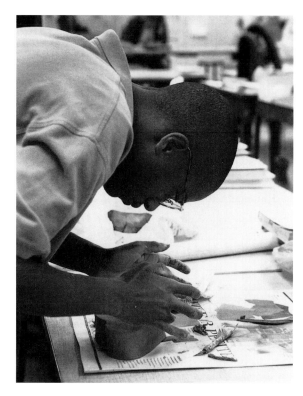

Art-making is the process of responding to observations, ideas, feelings, and other experiences by creating works of art through the skillful, thoughtful, and imaginative application of tools and techniques to a medium.

is thoughtful making that is sought, the manipulation of chosen materials with techniques that are selected because they help students accurately, appropriately, and effectively convey and communicate their thoughts, ideas, and feelings. For example, students might reflect upon what could form the beginning of an "artistic idea." What is the role of chance and accident in the making process? How does one know when art-making is completed?

By focusing upon different aspects of art-making, students can obtain a richer experience because they will be better able to understand how artistic processes work. For example, there is much to explore in considering the utility of play and improvisation, and the influence of variation and correction, in the making of art.

How is the "unrehearsed" fundamental to art-making? What examples would demonstrate how the artist leads by exercising an innovative style or expression, but at the same time follows in the sense of walking in the footsteps of artistic traditions to which artists are educated and attracted? By thinking about and discussing the motivations and phases of the creative art-making process, students can more clearly understand how art-making is linked to a knowledge of history, criticism, and philosophy.

Rather than being riders in a car with no sense whatsoever of how the vehicle is propelled, students can come to better appreciate what fuels artistic creativity and how

the artist steers an artistic idea over the terrain of a potential medium. Students may be drivers as well as riders, learning to delineate how their own artworks relate to those of other artists. Discovery, experimentation, and technical problem solving are all possible outcomes of inquiry-based art-making. Students are likely to learn about the possibilities for art when their attention is directed to examining the practices by which art objects are actually achieved.

There are many facets of art-making that may be explored, studied, and experienced by students, and there are many appropriate questions to raise with students about artists and their work even while students practice the skills of art-making and create their own art:

- Students can become familiar with a wide range of art media, tools, equipment, and techniques used by artists, as well as the themes, subject matters, symbols, and other source materials that feed and shape the art-making. What might have been the sources of the artist's visual idea and how are these eventually manifest in a given art object?

- Students can learn about traditions of craftsmanship, including respect for and the ability to utilize the potentialities of materials. What are the steps involved in working in a given medium to make it ready for the artist to use? What do artists mean when they speak of the pleasures of handling and working with certain materials? How might the arrangement of one's work environment, as in the artist's studio, influence or support art-making? What are the impacts of work habits on the production of art objects?

- Students can express thoughts, values, and feelings in visual form by accessing ways of responding and working that have been developed by artists. Is the artistic impetus or idea a new one, is it a variation on an old or established idea, or does it build through elaboration or revision of other work or tradition?

- Students can learn about visual problem solving, in which art-making occurs through a sensed artistic resolution of the tension between opportunities presented and restraints encountered. What processes does the artist appear to utilize in order to work out a visual solution? Can one distinguish those that are

ineffable, subjective, and perhaps spontaneous from those that are deliberate? How much planning or deliberation is necessary before one begins art-making? What is the role of chance and serendipity as the work unfolds?

- Students can learn to understand the motivations and attitudes of artists by reading about their lives and appreciating their roles and contributions to society. Attention can be directed to the personal, social, and universal ideas and issues that have been the source of artists' concerns and imagery. How might the creative work of artists depend upon the character of their lived experiences? What do devotion, dedication, and satisfaction have to do with making successful works of art?

- Students can appreciate the various contributions to an artist's work from artistic training and experience, including the cultural and social histories from which the artist draws inspiration and ideas. Students can develop the personal qualities required for successful artistry, such as persistence, patience, and self-awareness.

ART CRITICISM

What Are the Functions of Art Criticism?
Art criticism entails describing, interpreting, evaluating, and theorizing about works of art for the purpose of increasing understanding and appreciation of art and its role in society, as well as for many other purposes. Therefore, art criticism includes the use of language, thoughtful writing, and talk about art through which we can better understand and appreciate art, artists, audiences, and the roles of art in culture and society.

Art critics look at works of art and respond to them. They describe, interpret, judge, and theorize. Words and language are the media through which art critics report their encounters. Art critics ask fundamental questions about what is there in a work of art (perception and description), what it means (analysis and interpretation), and what its worth or value is (judgment); they also discuss the nature of art (theory).

Art critics and art educators offer diverse and wide-ranging views about the function of criticism. For example, the philosopher and educator John Dewey said that criti-

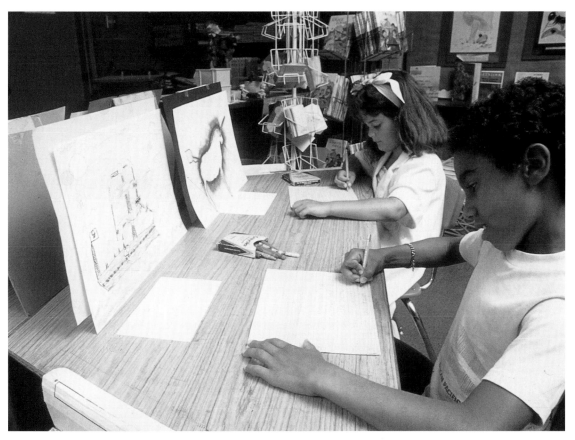

Students learn the skills of art criticism so that they can look critically at and respond to the art of others as well as their own.

cism is the reeducation of the perception of works of art, and the philosopher and art educator Harry Broudy called the purpose of art criticism (and the larger aim of aesthetic education) "enlightened cherishing." Many different but related functions have been ascribed to the discipline of art criticism:

- The art critic cultivates artistic perception by helping us to understand how visual and tactile qualities, and other properties in a work, combine and operate to convey aesthetic and other meanings.

- The art critic makes a reasoned assessment of artistic quality, based upon stated criteria and the comparison of the work with other art objects, either by the same artist or others within a given artistic tradition. But it is also important that the work be seen outside of the art world, as a cultural artifact that may function in other ways.

- The art critic improves the intellectual environment in which we think about art, by developing reasoned justifications for appreciating and valuing various forms of artistic enterprise. This is especially important in our multicultural society.

- The art critic helps us to appreciate art's multifarious values, by focusing upon the multiple levels of meaning and significance that are conveyed in artworks.

Art criticism did not arise from an academic tradition as much as from a journalistic one. Unlike art history, which has clearly developed as a discipline within the university and is extended both by the professoriat as well as by curators in museums, art criticism's stage has been newspapers, magazines, and television, where descriptive, interpretive, and evaluative reviews are offered for popular consumption.

This tradition has been reinforced by the complexity and general ambiguity of modern and contemporary art. For example, in the West, the classic or traditional aspiration of drawing and painting until the late nineteenth century was that of representation, in which resemblance to an external reality was the touchstone by which artistic quality was to be judged. With such historic artistic revolutions as impressionism, cubism, and abstraction, other criteria became paramount for ascertaining the significance or worth of artworks. The truth of pictorial reality no longer was seen to be a function of how "real" an image looked, how closely it matched the world of appearances. Art critics have played a major role in helping the general public know something about and better understand contemporary art.

How Has Art Criticism Evolved as a Field?
In previous eras, viewers could depend upon some measure of realism or even a helpful title to assist them in understanding a work of art. Art criticism arose as a reaction to the need for interpretation once the familiar frame of reference of realism was abandoned by many individual artists and movements alike. Art critics helped viewers understand works of art, those from other historical periods as well as contemporary works, whose meanings and significance were difficult to access.

This analytic and explanatory function is, once again, at odds with those who believe the meaning of the work is to be found only in the direct, unaided apprehension

of it. For this reason, art criticism is generally written not for artists, but for viewers and connoisseurs who need and welcome assistance in their encounters with works of art.

Art critics look at art not in an abstract or idealized vacuum, but as an important component of contemporary culture. Therefore, critics respond to the audience's need for guidance in assimilating and appreciating art at a time when artists often create complex and sometimes cryptic works. But critics do not restrict their attention to the obscure; they also take as their proper study artworks that are familiar, realistic, and ostensibly mundane.

In the West, the emergence of a discipline of art criticism was also paralleled in the latter part of the nineteenth century by the expansion of the press, as technological developments in high-speed printing made newspapers and magazines more widely available, followed in the early twentieth century by the rapid spread of the electronic media of radio and television. At the same time, a scholarly tradition of art criticism evolved that includes in-depth interpretive essays, which are published in specialized and professional forums such as journals and magazines or presented at seminars and conferences.

An early practitioner in the Western tradition who addressed works of art with an eye toward critical scholarly analysis was the writer John Ruskin, whose reviews of nineteenth-century artists such as Turner and Whistler provided scholarship in journalistic and popular forums. By contrast, Roger Fry, an Englishman who focused upon the "plastic values" or elements of design and composition in the work, which would become the preoccupation of contemporary art criticism, did not look at the social context of art objects. More recent critics, such as Clement Greenberg, Robert Hughes, Hilton Kramer, and Lucy Lippard, focus upon value judgments about art that are related to broader contexts rooted in the social milieu and the intellectual currents of the day. Writers like Tom Wolfe have been critical of practitioners who become removed from works of art through their discourse. They are seen as basing their criticism on reactions to other critics' language rather than ultimately to the works of art being written about.

The scholarly tradition in art criticism has also been reinforced by the variety of academic disciplines in which questions about art are posed, such as art history, philosophy, literature, cultural history, anthropology, and linguistics. Art criticism is, therefore, likely to be a composite of knowledge and skills drawn from a plenitude of different fields of study.

Art critics draw on the disciplines of art history, aesthetics, and art-making to do their work, which in turn informs those fields as well. Art critics do not operate in

a vacuum, but rather draw on these disciplines and others (cognitive science, linguistics, anthropology, and so on) to fashion informed judgments. One cannot be informed about art without knowledge of how the other disciplines contribute to one's understanding of the work.

In DBAE, the interpretation and reasoned evaluation of works of art are crucial to the student's understanding of art. In fact, all three of the other disciplines share in this task. Teachers of art-making, art historians, and aestheticians are all attuned to the critical investigation of art. This is due in part to the fact that the tools of critics are linked to the purposes of each of the other art disciplines. For example, art historians examine works of art with concerns for time, period, tradition, and style. The historian is acting as an art critic when he or she decides and explains why which of an artist's works from another time is the best or most significant. The artist as the maker of art is constantly reassessing the impact of various artistic decisions in proceeding to the completion of a work, decisions that an art critic might say play a role in locating that work within a tradition or "school." The aesthetician's inquiry is composed of a series of analytic processes, centered not so much on the work of art as on the talk about it, what the critics and historians say about works of art and how these claims and issues help us understand art's nature.

Art criticism helps us both to understand the meaning of a work of art and to appreciate its power. It articulates what makes a work compelling by drawing attention to those qualities or aspects that are essential to it. The interest of art criticism lies in determining what is to be valued or what matters most about a work. It is about significance and interpretation. Much more than simply apprehending the work clearly and completely, the art critic embraces the ambitious questions of the relationships of works of art, artists, appreciators, art culture and its institutions, and society.

It is useful to make distinctions between art criticism and art history. Art criticism tends to favor contemporary and relatively recent art, whereas art historians principally study and document art of the past, seeking to find what it meant to viewers of its own time. When art critics look at historical art, they try to make it relevant to today's audiences. Indeed, art critics may draw heavily upon art of the past (by way of reference or comparison) to support their critical insights about the newest art movements or even to make predictions about the art of the future.

Art historians, in turn, often look at the history of art as an unbroken continuum extending to the present day. They reject the suggestion that their interest and scholarly attention should wrap up around 1945. To some in the art world, art criticism functions as "short-term art history."

The principal responsibility for approaching the products of contemporary artists rests with art critics, who are intent on helping their audiences (whether academics, connoisseurs, or the interested public) understand the meanings of those works and the directions art is taking. Whether the venue is journalistic and popular or scholarly and academic, art criticism by various professional practitioners shares a number of general features:

- Art critics describe and interpret, and sometimes judge, by directing their audience's perception and by calling the viewer's attention to certain aspects and developments in a work of art and in other recent and contemporary art.

- Art criticism is often (though not exclusively) written and is, therefore, intended for an audience of readers (the interested public, museum curators, art dealers, collectors, students, gallery-goers, and other critics). However, in most schools, although students may read and write art criticism, it is most often used in verbal discussion.

- Art criticism comes in many forms, from columns and articles in newspapers and magazines to scholarly books. With the development of the television news-magazine, more art in museums and galleries is being reviewed in a "live" format. This reveals a high energy and enthusiasm for art by critics, who tend to be passionate about their views and often deploy language to be as persuasive as possible.

In recent years, art criticism, like art history, has been influenced by the application of a host of intellectual, social, and cultural perspectives that may collectively be called critical studies. These include deconstructionist theory, feminism, Marxism, psychoanalytic theory, structuralism, and other postmodernist approaches. Such studies and other intellectual currents have made the practice of criticism, including art criticism, both provocative and stimulating. The net impact of these perspectives has been to challenge some basic assumptions about the roles, functions, and sources of criticism, history, and philosophy. For example, with regard to criticism, deconstructionist theory and semiotics have exposed the limitations to which language is subject. In general, with increased knowledge about non-Western cultures, the horizons or territories of affected disciplines, like art criticism, have been expanded.

What Issues Can Students Focus on in Art Criticism?

In the DBAE classroom, the intent is to demonstrate how art criticism requires careful observation of works of art, those made by students and by mature artists, as in the comparing and contrasting of works and the consideration of social and other contexts in which they are produced. Oral or written questions to be asked of students might include the following:

- What is the subject or theme of the work? What does the subject matter or theme of the work say about the intentions, interests, or social or political concerns of the artist?

- How do the visual and tactile elements contribute to an effective and meaningful statement? What are the significance and meaning of the objects, nonobjects, or visual effects in the work?

- What do critics say the work means, and how is the work regarded overall in the development of the artist and of other artists?

- How does this work of art function in society? How do different audiences relate to or interpret this work? How does its context influence its meanings?

- Does the work provide a satisfactory aesthetic experience? Does it sustain attention and involve active discovery of new things?

ART HISTORY

What Contribution Does Art History Make?

Art history involves inquiry into the historical, social, and cultural contexts of art objects and focuses upon the aspects of time, tradition, and style as they relate to works of art. The essential purpose of art history is, therefore, to establish and sustain a systematic order in the cultures and traditions of art.

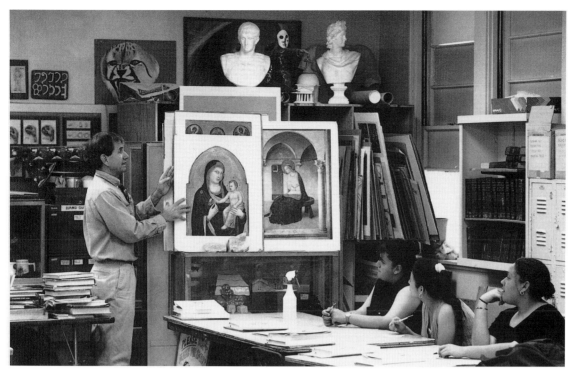

Art history leads to inquiry and learning when the emphasis is on discovering and re-creating knowledge.

In its Western and conventional form, art history entails the construction of narratives and genealogies that organize and examine the history of art in terms of chronologies, artistic movements, and stylistic traditions. For generations of American college art history students, texts such as those by Gardener and Janson have sustained that legacy, which continues to play an important role in the teaching of art history at an introductory or survey level.

Such art history puts a premium on broad but supportable generalizations about artistic periods such as the Renaissance and the romantic era. This form of art history addresses the art education goal, described by the National Endowment for the Arts in *Toward Civilization,* of giving young people "a sense of civilization," intended to mean not only a sense of Western civilization but of Eastern and non-Western civilizations as well.

The contributions of art history to broad educational goals and to general ways of thinking are also coming into view as educators prepare new substantive standards for art as a subject field. For example, the concept of *historical thought* can be embedded in experiences that acquaint students with the processes of causation, change, continuity, motivation, and evidence. These may be explored as elements that influence the development of art. Similarly, the concept of *historical imagination* is educationally accessed through

art history when students entertain ideas and speculate about the beliefs and values of other people and cultures as expressed through their art.

But art history's functions are more varied than just providing sweeping vistas of human visual and cultural achievement. Following the axiom, as with art criticism, that the discipline is largely defined by what its practitioners do and say, one would have to pitch a very large tent to accommodate all of the different purposes served and activities engaged in by art historians. Art historical inquiry, in addition to imposing order on the history of art, also includes

- creating precise re-creations of buildings and monuments that have not survived into the present time, as when architectural historians helped re-create the Villa Papyri from ancient Herculaneum in the form of the J. Paul Getty Museum in Malibu, California;

- conducting archival investigations that document various features or provide evidence of influences on the works of an artist or art movement, as when the Archives of American Art (a unit of the Smithsonian) collects for scholarly use the letters and diaries of American artists;

- reinterpreting imagery that has been ignored or neglected in the past, as when feminist or postmodern art historians focus on previously unappreciated works of women artists or those who did not enjoy the patronage that bestowed artistic success in their day;

- conducting chemical and radiographic (X-ray) analyses to build knowledge about a work, as when a museum curator or connoisseur suspects that the materials and techniques hold the key to unlocking important new information about a work of art;

- tracing the life history of a single work of art, or preparing a catalog and exhibition in a museum to trace the lifetime work of an artist or artistic movement, as when curators and exhibition designers demonstrate the evolution of art and artistic style; and

- investigating the perceptions of audiences (patron, public, user) at the time a

work was created and ascertaining the existence and influence of artworks of other times and cultures.

All of these activities are forms of art historical investigation. In fact, the term *art history* refers simultaneously to the history of art, which is the subject of disciplined inquiry, and to the academic and scholarly field in which practitioners carry out the sorts of activities noted above. Like some art critics and most aestheticians, art historians are to be found in academic settings, such as colleges and universities. They are also prominent in museums, where the professional credential for curatorship in most institutions is a graduate degree in art history.

How Has the Study of Art History Changed? The discipline of art history has its own history that is

of interest to those who are intellectually curious about the origins of the practice. For example, in the Western tradition Giorgio Vasari was a Renaissance painter, architect, and writer whose *Lives of the Most Eminent Painters, Sculptors, and Architects* (1550) was the first effort to organize individual artist biographies into an integrated account.

Art history as a discipline in the university began in the late nineteenth century, with two scholars in particular dominating the field for much of the twentieth century. Heinrich Woefflin's great contribution was in creating principles of style and analysis so that the historical period, national, and personal features of works of art could be recognized, tracked, and examined. By using such a methodology, researchers determined that at least 14 different artistic hands sketched the animal drawings in the prehistoric caves at Lascaux. Woefflin also devised the concepts of "linear" and "painterly vision" and "planar" and "recessional space," among others, to describe the relations of parts and wholes in Renaissance and baroque art, concepts that have proven useful in describing artists' approaches to style in general.

Another significant scholar in the European tradition that shaped generations of art historians was Erwin Panofsky, a humanist who saw works of art as the primary materials for cultural study. Panofsky gave art historians powerful tools for study by developing the concepts of iconography (literally, "image writing") and "iconology" (the relating of a work to a world outlook), through which the meanings in works could be deduced from study of subject matter as opposed to the form of the composition and its relation

to its cultural context. Today we would say that there are several nontraditional or alternative sources through which one can ascertain meaning, in addition to the subject matter of a work of art.

In the second half of the twentieth century these traditional approaches, while still respected by most art historians, have been expanded by new perspectives. Nontraditional methodologies, such as those of constructionism and deconstruction, feminism, Marxism, and semiotics, now complement traditional forms of interpretation and explanation. Previous assumptions about the appropriate arenas and sources for art historical inquiry have yielded to a wide-ranging and open definition of historical process. Art historians have always looked at art in its context, but it seems that today there are more theory and value systems competing in the marketplace of ideas than ever before. Nontraditional approaches are therefore in increasing favor, because they allow teachers and students to explore the history of art in many different, flexible ways. By shifting the focus to the vernacular, to a more personal, everyday experience, the history of art becomes more accessible. Art history can be a prime example of inquiry learning when the emphasis is not on preexisting knowledge as much as it is on discovering and re-creating knowledge.

The extended or nontraditional approaches to art history draw, as does art criticism, on a number of other disciplines to support inquiry. Sources for art history now include anthropology, archaeology, intellectual history, linguistics, literary theory, psychology of perception, political science, psychoanalysis, sociology, and theology, among others. An encompassing philosophy or methodology of art history (or of art criticism or aesthetics) recognizes the value in multiple perspectives and forms of inquiry.

What Types of Inquiry Are Conducted in Art History?

In traditional art historical scholarship, a number of basic questions are asked about a work of art in order to contextualize it. These questions may or may not be appropriate for all works—for example, some non-Western and nontraditional works. Some of these are inquiry issues (attribution, authentication, iconography, provenance), whereas others focus on different aspects of the work (function, psychology, style):

• *Attribution:* Where, when, why, and by whom was the work made?

- *Authentication:* What scholarly confirmation is available to document the attribution of the work?

- *Iconography:* What are the meanings of the objects and symbols in the work?

- *Provenance:* What is the history of the ownership of the work?

- *Function:* What was the original purpose of the work and why was it created?

- *Style:* What are the distinguishing characteristics or qualities that identify the work and relate it to other works of art?

- *Psychology:* What personal factors (family, personality, friendships, and so on) help relate the artist to his or her time and the work to a particular social or cultural milieu?

- *Connoisseurship:* What does intensive study of the work reveal or help resolve with regard to problems of authorship, ownership, or physical condition?

Art historians have created a huge literature in which the above concepts are employed and their judgments recorded. The ongoing work of museums and the art historians and curators within them stimulates new art historical inquiry and directs much of it to practical issues that are resolved in exhibitions and publications. Considerable scholarship has been expended on questions of attribution, iconography, provenance, style, and other such concerns.

At the same time, there is the promise of discovering and creating new art history, not just revisiting what has been the subject of scholarly attention in the past. Many art historians now devote their attention to unearthing new art that has not yet been categorized by other historians and experts and to learning about artists who may still be unknown within their own cultures. This includes women artists such as Artemisia Gentileschi, Judith Leyster, Angelica Kauffmann, Margaretta Peale, and others whose work has become better known due to recent scholarship.

As the art of a historical period is examined in the context of and subject to the influences of political, social, religious, and economic eras, which are a primary staple

of the large undergraduate or interdisciplinary humanities courses, it becomes clear that some broader agenda is in view, what one might call "cultural history." Art history is that portion of cultural history that deals with works of art, with visual images that have been fashioned, valued, and handed down across the generations.

Art history seeks to understand how such art functioned in its original context. In a practical sense, art history is the art of writing about, providing explanations for and interpretations of, the art of the past, based upon evidence gathered from a wide variety of sources. In traditional art historical scholarship, evidence might be summarized in the following types of information that art historians search for, compile, analyze, organize, and utilize:

- *factual information* about artists, such as birth and death dates and where they worked, and about works of art, such as their physical description, subject matter, and circumstances of their creation;

- *formal analysis* of the work, describing and analyzing the web of relations in a work (color, spatial, and so on), as a basis for understanding how the work fits into a specific artist's oeuvre (body of work) or an artistic movement or tradition;

- *technical analysis* of the work, including information about materials used, tools and procedures applied, and changes in the object resulting from passage of time or other environmental impacts; and

- *contextual relations,* or the relations of the artist's choices and outcomes to historical circumstances and to the social, political, and cultural milieu in which a work is produced and for which influences of varying kinds (including other works of art) may be cited (emphasis here will be on how the work functioned in its own time).

The study of art history as a discipline therefore offers, among others, the following types of inquiry:

- assessing and understanding works of art in light of broad social, political, and

cultural themes and events, underscoring art as a significant and important form of human activity, recording, and accomplishment;

* learning how people in various times and places identify with and find meaning in works of art from their own and other historical eras;

* studying the history of art-making and artistic achievement in terms of traditional stylistic eras and movements, and examining the explanations and interpretations provided by art historians;

* approaching works of art in terms of biography, emphasizing the social and cultural milieu that resulted in the production of certain works by various individuals, groups, or movements;

* analyzing the accomplishments of various artists whose works have been recognized and valued by society and preserved for future generations to experience; and

* investigating works of art to determine their origins, histories, meanings, and influences upon subsequent art and artists.

The theme underlying all of these forms of inquiry is the active, participatory engagement of the student with works of art and the written material through which art historians have shared their discoveries, research, insights, and theories. Students can, of course, engage in the art historical process themselves by examining the provenance of, say, a family heirloom or another work of art available to them for sustained study. Imaginative art teachers who teach art history involve students in actual historical inquiry, not just the study of the history of art as it is brought to us by art historians. Students make art, criticize it, philosophize about it, and should also do historical inquiry of it.

Material for art historical studies appears in both scholarly and popular books available in many bookstores, and especially in museum and gallery bookshops. Video stores and museum shops now sell video and laser disc materials that provide additional resources. Many museums, looking ahead to the twenty-first century, are having their collections digitized; the resulting CD-ROMs offer the promise of detailed, high-resolution

imagery for art history students of all ages. Internet access to museum collections also provides teachers with new tools for art historical inquiry.

Finally, the advent of virtual reality simulations will allow art historians to re-create and preserve, in electronic form, the lost or damaged art of the past. Examples of this work include the Getty Conservation Institute's interactive reconstruction of ancient tombs in Egypt and the Getty Education Institute's virtual reality reconstruction of Trajan's Forum in Rome.

AESTHETICS

Why Is Aesthetics a Foundational Discipline?

As the name of a discipline, *aesthetics* functions as both noun and adjective. In the former sense, the field of aesthetics is that branch of philosophy in which questions are raised and examined about the nature, meaning, and value of art, and other things, from an aesthetic point of view. The study of aesthetics in this sense helps students to understand what distinguishes art from other kinds of phenomena, the issues that such differences give rise to, and how one may justify judgments about art objects. Aesthetics thus helps students learn to examine the bases upon which artists, art critics, art historians, and other disciplinary specialists make informed interpretations and judgments about art.

Aesthetic is also used to refer to a particular kind of experience one can have with any phenomenon. Albert Einstein spoke of the elegance of a complicated mathematical proof. The sense in which such a proof can be perceived as elegant lies in an individual's response to the form, appearance, and character of it, rather than its truth-value. This is an aesthetic judgment. One may aesthetically experience a beautiful sunset or, for that matter, an inelegant but curiously formed piece of driftwood on the beach.

Aesthetics therefore includes the study of the special qualities of the aesthetic experience and its unique contributions to human life and culture, with the complexities and subtleties of aesthetic experience ranging beyond works of art. For the purposes of DBAE, the focus of aesthetics is on the visual imagery of art objects.

One limiting perception of aesthetics is that it is conducted only by philosophers, who carry on esoteric dialogues in universities (and some of them do). The kinds of inquiries aestheticians mainly pursue, however, are similar to those that schoolchildren

might make. When a child says, "That picture is pretty," he or she is making a critical statement. At first blush this may seem a straightforward and simple report, but consider how potentially complicated such a claim can be, and the levels of meaning that might be distinguished to appreciate fully the subtlety of that child's declaration.

What is the utility and meaning of such talk? The discipline of aesthetics helps teachers and students access and understand the nature of art in terms of such inquiry. Does the child mean (consciously or not) that the subject in the picture is pretty, or that the painting itself (which may be of an "ugly" subject) is pretty? Are paintings of ugly subjects also ugly? Could an artist not make a pretty portrayal of an ugly thing? Are there differences among ugliness in nature, in people, in paintings? In any case, what sense can we make out of such visual descriptors as *pretty* and *ugly*? Are these entirely relative terms, dependent on the eye of the beholder?

How are these terms related to cultural learning? How do they vary from one place to another over time? How are they affected by the nontraditional, non-Western work of art, which may not be viewed by its makers or audiences as being at all about beauty? What should we make of the efforts of some contemporary artists to move away from traditional concepts of the beautiful, or to create objects that deliberately reject assumptions about beauty in art?

Consider the *Star Trek* science fiction television series, which has taught an acceptance and respect for the possible differences among life forms that are assumed to exist throughout the universe. To so-called alien forms of intelligent life, the human body may appear far less than "beautiful." When our basic assumptions about beauty are challenged, we may find ourselves much less certain about exactly what it is and how it comes into being. Different species are likely to have different aesthetic assumptions, preferences, and traditions.

Certainly there is a social character to such concepts. In the United States the advertising industry, television, and motion pictures have had considerable influence on societal views about beauty, reinforcing stereotypes that students carry with them into school classrooms and eventually into discussions about art images. But a discussion about the compelling power of a television commercial is not aesthetics; it is a lesson in visual literacy.

Aesthetic inquiry occurs when we examine the statements and judgments we make about imagery to determine what conception of beauty or other value systems they represent, and how these may be justified. In any case, we know from art history that what was considered beautiful and esteemed in one time and place may be rejected

in another. The endless permutations of art must be considered in the larger contexts of social, cultural, and personal value to determine the meaning that works of art had or have for different audiences.

What Is the Philosophical Tradition in Aesthetics?

Traditionally, aesthetics has been occupied with the most basic philosophical questions about art, such as, What is the essence of art? Philosophers' search for art's essential character can be traced in Western philosophy to Plato and Aristotle, who formulated a theory of "mimesis" (art as imitation of reality). Systematic observations about art were subsequently made by St. Thomas Aquinas, Kant, Hegel, Nietzsche, and Schopenhauer. In the twentieth century, aesthetic inquiry is featured in the writings of Bell, Beardsley, Croce, Danto, Dewey, Fry, Goodman, Hospers, Langer, Osborne, Santayana, and Sparshott.

These and other aestheticians have been animated by such questions as, Do special qualities or properties exist in art objects so that we know when we are in their presence? Or is the essence of art defined by certain intentions and functions to which art bears witness? These types of questions represent what might be called the essentialist view, a search for defining characteristics that all works of art must presumably have. Conversely, some Western writers have sought to understand works of art in a non-essentialist fashion, such as the English philosopher R. G. Collingwood and the Russian novelist Leo Tolstoy, who explored the expressive character of art.

A different perspective, classically articulated by the philosopher Morris Weitz, is that no definition of art is capable of capturing the essence of art in terms of its perceptible features. It is therefore futile, claims Weitz, to try to impose a definitive set of conditions, because any such formulation would be ultimately challenged by artists who create new objects and images not covered by the definition. In fact, a society such as ours, which cherishes artistic innovation, sets up in advance conditions that make it impossible to predict or assimilate all of the aspects of new works of art.

Instead of searching for definitions of art that will have universal validity, then, Weitz recommends that we regard all definitions as honorific, as attempts to persuade viewers and artists to attend to certain aspects of art and not to others. One can say the same thing about definitions of education and art education. When art educators emphasize certain art activities and outcomes, these in effect become recommendations to act

on. Some writers have called such definitions *programmatic*, meaning that they convey a worthwhile vision of what teachers should do. When we try to utilize such definitions, whether in art or in art education, we are simply favoring some aspects over others.

Weitz's view, however, has not gone unquestioned, and the search for art's essence continues, if not in terms of perceptible defining properties then in terms of a characteristic function that is psychological, intellectual, or social. An example of a definition in terms of a characteristic psychological function would be Monroe Beardsley's definition of art in relation to its capacity to occasion worthwhile aesthetic experience. Or we may speak of Nelson Goodman's definition of art in terms of a characteristic cognitive function to provide understanding.

An example of a social definition would be George Dickie's institutional theory of art, which holds that social and cultural institutions and their practitioners (curators in museums and galleries, critics writing for the popular or the scholarly press, collectors and connoisseurs working with art dealers, and so forth) define art by conferring status on some objects and not others. Art is what the museum director says it is, and it is validated by costly exhibitions, which can have ripple effects in the art world (the art marketplace, the scholarly community, and so on). Most observers will react against this concept of authority, but at the same time they must acknowledge that the institutions of the art world have powerful impacts on the status of artworks.

What is more, the institutional theory that interprets art in light of the ideas and conventions of the art world is value neutral. It gives up the attempt, typical of most aesthetic theories, to include value dimensions in definitions of art. While acknowledging that the quest for an essential definition of art goes on, for purposes of DBAE it is best to regard all definitions of art as persuasive, programmatic definitions. These are invitations, as Weitz puts it, to entertain varieties of excellence in art. Likewise, interpretations of DBAE may also be regarded as programmatic definitions of art education.

How Can Students Become Engaged with Aesthetics?

Many aesthetic issues and concerns emerge in the DBAE classroom in the course of inquiry about works of art as students explore art-making, art criticism, and art history. The content of the other three disciplines gives rise to aesthetic questions. For example, following the critic Arthur Danto, the teacher might suggest to students that an object becomes a work of art through the act of inter-

pretation. This puts a premium on the students' effort to understand the work in critical and historical contexts.

Aesthetics directs attention to the act of artistic creation, the art object itself, its interpretation and appreciation, critical evaluations, and the cultural and social context. Aesthetics is specifically about teaching children to think philosophically and about examining the questions and possible answers that occur naturally in the course of making, enjoying, and discussing art. For example, if we think about some of the issues that are raised by our interactions with art, the following interesting questions emerge:

- Are the meaning and significance of a work of art in the work, external to it, or both?

- How can we assign value to what various perceivers say about works of art?

- Should artworks that are deemed sacred, privileged, or private by groups within one culture be publicly displayed by another culture for all to see?

- In weighing the value of expert and academic testimony about works of art, to what extent should a viewer substitute his or her own personal perceptions, ideas, and judgments for the conventional wisdom?

- Is the erasure of a drawing the destruction of an existing work or the creation of a new one?

- Should we honor the deathbed request of an artist who wants his unsold works destroyed? Do aesthetic objects have a "life of their own" that entitles them to protection? Is there a moral imperative not to destroy art?

- Do citizens have the right to remove public artwork, paid for through taxes, if some members of the public find it is offensive? Who decides? What arguments would make the case one way or the other?

Discussion of such issues, sometimes called aesthetic puzzles or case studies, when skillfully managed, can result in its own intrinsic motivation. Concomitantly, such engagement with the ideas and values surrounding works of art encourage and enrich interpretation.

Aesthetic inquiry ratchets up the level of consciousness involved. It puts students in touch with the complex and subtle issues and meanings that potentially surround works of art and helps them to think more clearly about such works.

Students' understanding of the discipline of aesthetics may be considered as a continuum. For example, for young children, a developmentally appropriate initial involvement in aesthetics may be to learn the distinction between expressing a preference and making a judgment. Such young students can be assisted in understanding that although they may like a particular work of art, there are other students who may not like it. Aesthetics is not about uttering subjective preferences, but about the thinking and effort involved in figuring out why we make such choices and how best to support and justify them.

It is similar to being asked what kind of ice cream one likes the best. There is no right or wrong answer, nor is it even a question of aesthetics. It is simply a matter of individual preference, inconsequential except for the individual making the selection (and perhaps for the ice cream company). But to assume that anyone else would value one's choice of ice cream requires a set of reasons supporting a judgment of its goodness. Here it is incumbent upon one to create a rationale for one's choice, to make a reasoned judgment capable of meeting some external standard or criterion other than one's own preference. This is the ideal of objectivity. The discipline of aesthetics involves teaching students how to create such arguments, how to talk about artworks in a manner that validates the judgments they have made about those works.

Aesthetic discussion conducted with younger children should be consistent with their levels of intellectual and psychological development and their mastery of language. In fact, students normally carry on aesthetic inquiry by virtue of being engaged in almost any type of art study. Although younger students may discuss issues about art in a less advanced way than older students, and without using technical jargon, they are doing aesthetics whenever they confront the types of problems described above. Simply learning to talk and construct a reasoned argument is an important exercise, not only for aesthetics and art education, but for the general educational goals of schooling.

More mature and experienced students in art will, of course, be expected to operate at a more sophisticated level. For example, at a higher level of learning, students might be introduced to the philosophical systems devised by aestheticians in their consideration of the changing nature of art and the meanings, issues, and concerns to which this gives rise.

3

Features

How Do the Disciplines Provide Different Perspectives on Art?

To use a visual metaphor, the disciplines of DBAE provide lenses through which individuals can create, understand, and appreciate art. Each lens directs attention to particular features of works of art. In fact, each discipline serves as a lens through which the individual gains a particular perspective. Each of the art disciplines may itself host a variety of different points of view that encourage multiple interpretations. Using a particular lens or set of lenses, the viewer becomes aware of aspects of an artwork that, with an unaided eye (and mind), would be far less likely to strike his or her consciousness.

The disciplines therefore provide useful ways of encountering works of art and construing their possible meaning. Some disciplines direct attention to specialized aspects of works of art. For example, the art history lens helps students acquire insights about other peoples and their artifacts. In some parts of Africa, masks were often originally created for purposes other than to be hung on walls like pictures, as we find them in many Western museums. Masks were made to be "danced" in communal ceremonies. Thus certain African visual "art" was created with a strong performing purpose and function. If one simply sees such an African mask on a wall in a museum, one might miss the entire point of that art object. At the same time, the exotic and decorative functions and pleasures of such artifacts can be appreciated. Other lenses are broad and more abstract, such as the lens through which art historians make generalizations about the meaning of symbolic subject matter in, for example, Renaissance sculpture or in Sung-era Chinese scroll paintings.

Sometimes a lens can be narrow, restrictive, or reductionist. An example is the traditional elements or principles of design approach, in which observations and talk about art are based upon a formal analysis of the plastic properties of a composition (shape, color, texture, and so on). This approach teaches young children to see shapes and lines, for example, rather than to look for meanings supported by the shapes, lines, and other design elements. Of course, all art has form, but we do not need to start (and too often remain) with form when we look at art. Some art is primarily about form (such as abstract expressionism), but most is not.

However, although many art educators do not believe formal analysis is good educational practice, it continues to be featured in many state and district curriculum

guides. In the early days of DBAE, this approach was sometimes called "aesthetic scanning," but it was only one of several available tools for accessing works of art and was inappropriate when applied to many multicultural and contemporary works.

What Are the Sources for the Disciplinary Perspectives?

Specific sources of information and ideas for the various disciplines of art include the *discipline knowledge base*, the accumulated knowledge, attitudes, and values that make up the content of a given discipline. The knowledge base includes the history and evolution of the discipline, its "lore," and its processes of inquiry in the field. Although these are treated as discrete for purposes of explanation, in practice the disciplines often overlap and interact.

Also of value as sources are the written accounts, self-reports, and demonstrations of *discipline practitioners* (artists, art critics, art historians, and aestheticians) who reflect on the nature of their respective disciplines and their practices. In fact, the practitioners of many other disciplines may also be involved with art study, such as architects, cultural anthropologists, folklorists, and sociologists.

The application of the disciplinary lens is most educationally effective when the relationships that exist among and between the disciplines are themselves productively explored. A single discipline experience in art is unlikely to provide students with the array of experiences and benefits that a comprehensive approach envisions. Rather, students' experiences should be enhanced and made more holistic through the integration of the four foundational disciplines, each of which is characterized by its relationship to works of art.

Experience has shown that in the early stages of DBAE, teachers seek to understand the distinctions that separate the individual disciplines. Once they are comfortable with these, they become more willing to explore the commonalities and interrelationships among the disciplines.

An increasing sense of connection and integration among the disciplines has evolved in DBAE professional development programs. By becoming engaged in developing instructional units, teachers have learned to combine and fuse the content of the disciplines. Using works of art as the focus, these units utilize the disciplines as means through which the works are understood, not as ends in themselves. This approach has created

satisfying relationships and comfort levels for teachers navigating between works of art and the disciplines.

Art museums and galleries provide students with optimal opportunities to experience the different perspectives of art. The museum is a primary community resource for introduction to the world of art through original works of art. There the values of the artist, art critic, art historian, and aesthetician are embedded in the study, exhibition, and conservation of works of art. There is no other public place where the multiple discipline components of the art world are so clearly present. There are also other places in which works of art may be seen and experienced, however, such as architectural settings (a downtown office building), neighborhoods (a mural in the barrio), works displayed in public places (airports, parks, transit stations), and within students' own homes (a quilt in the bedroom, a teapot on the stove).

How Do the Disciplines Overlap and Interact?

Ultimately, the ambition of DBAE is to combine, synthesize, and unify art instruction so as to provide educationally significant content, with four art disciplines as the source (not the focus) of learning in a truly interdisciplinary approach. By examining an art object from the perspectives of all of the four disciplines, one may expect to arrive at a fuller and more unified apprehension of the work. Applying the distinctive disciplines brings selected features into focus while perhaps relegating other features to the sidelines.

This is intended to lead to a holistic and unified experience with the work, not a series of separately articulated responses. The art disciplines in an interdisciplinary context are utilized symbiotically. Ideas, concepts, and themes underlying works of art are available to be illustrated by the disciplines individually or collectively. *Interdisciplinary* also refers to the fact that a work of art, like any subject matter, may be examined in the light shed on it by many perspectives: philosophical, historical, cultural, and so on.

The significance of the interdisciplinary approach may be understood through an artistic metaphor. When artists set out to draw, paint, or sculpt, they do not ordinarily and consciously "organize" the experience along disciplinary lines. Rather, there is a merging of interests and competencies that elicits a simultaneous, seamless derivation or utilization of ideas and experience from all of the foundational disciplines.

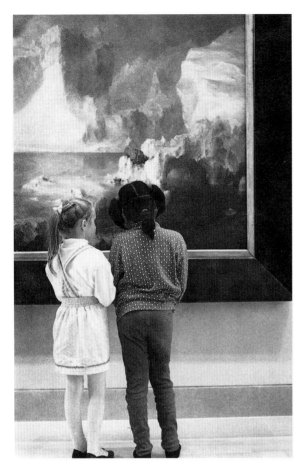

Disciplines are useful for understanding works of art and their possible meanings.

The lenses interact and overlap. For example, as an artist puts chalk to paper or brush to canvas, there is a coming together and fusing of (a) the artist's observations, ideas, feelings, values, and intent to draw upon these as a source for art-making, to create an object shaped by the application of the artist's technical skills in a medium; (b) the activation of the artist's capacity to create meaning through the arrangement and composition of visual forms and properties in the work, the use of symbols, and the relating of the work to other works that may have influenced the artist; (c) a demonstrated familiarity with both the artist's own and others' artistic products, and an understanding of those creations in various historical, social, and cultural contexts; and (d) the operation of implicit assumptions about the nature and meaning of the artistic act, the work created, the issues or questions it raises, and the judgments made about it.

Just as one would look to artists to obtain knowledge, understanding, and skills about making art, one can turn as well to the art critic, art historian, and aesthetician to learn more about their respective arenas of idea, craft, and practice. The focus on the practitioner in an art discipline is analogous to the tradition in other subject areas of

consulting and depending upon the role models who are "guardians" of those disciplines, such as the mathematician, social scientist, physicist, or journalist. At first it may be difficult to label or clearly identify the source of certain knowledge and statements about art. The writings of art critics and art historians are sometimes indistinguishable from one another, due to their extensive use of one another's ideas. For example, the critic draws on the historical and social data developed by the historian in order to understand contemporary art's relationship to previous artistic traditions. In turn, the historian can view the long train of art as leading to contemporary developments reviewed by critics.

Similarly, the artist who is well educated in art is familiar with the different domains of art. Many artists know some art history, perhaps in a very broad sense or in terms of highly specialized eras, movements, and other artists. Artists also draw upon many other sources. Thus one may create sculpture or textile designs that utilize images and motifs drawn from the history of art, but also from formal schooling in related disciplines (anthropology, cultural criticism, and so on) and from the influences of the surrounding community values.

Aestheticians, too, have mutual and overlapping interests that feed the possibilities for an integrated approach. They probe and speculate about the assumptions that underlie the work of artists, art critics, and art historians. DBAE lends itself to this kind of interdisciplinary art experience.

PROGRAM REQUIREMENTS

Why Is Arts Advocacy Necessary? The struggles to establish art as a subject in general education that have taken place over the past several decades demonstrate that before a successful program in art can be implemented, it is first necessary for teachers, administrators, and educational policy makers to understand the reasons art is important and what art can accomplish for students in schools.

In the past, appeals for the inclusion of art in the curriculum were often based on underscoring the need to address creativity and the personal and social development of the student. Although this was a valuable and humane orientation, it unfortunately neglected the full potential and educational benefits of art. Today, the same questions are asked: What does art provide for human development? Why is art an essential ingredient in students' educational success?

Practitioners of DBAE recognize that educators must face such issues in order to gain the confidence and support of parents, administrators, and other faculty colleagues. The importance of extensive research in human development that is conducted to further our knowledge of learning processes and the impacts of art instruction and experience is acknowledged.

Based on theory and data, multiple rationales for art may be offered. For example, (a) art helps students access their own civilization and those of others; (b) art teaches students to communicate in different ways; (c) art promotes inquiry processes in students, such as observation, description, analysis, and judgment; (d) art helps students learn to solve problems and to make choices; and (e) art teaches students appreciation and offers them insights about the extraordinary power of the human imagination.

Informed advocacy for art education is, therefore, the first step in preparing the ground for a DBAE program. Before any school or district commitment to a comprehensive program in art is likely, especially in the thousands of school districts with no history of such programs, people who are not familiar with contemporary art education would benefit from understanding the dividends it pays. Part of the learning curve is for educators to become acquainted with such arguments and to develop the capacity to advocate them.

This advocacy is a *political* activity because proponents of every subject area in the school program are working all the time to advance their respective interests. Advocates do this by seeking curricular priority, increased resources, and the support of administrators and policy makers. School board decisions are often driven by the public's perception of what ought to be important in the classroom. For art to survive and prosper, advocacy must be carried beyond the school and into the community in which the school functions. That community provides cues and support to policy makers on school boards and in legislative bodies that fund educational programs.

Art advocacy is also an *academic* activity, because the development of DBAE relies on a variety of efforts taking place in colleges and universities:

- *Theory formulation* helps build rationales for advocacy and platforms for designing and implementing successful DBAE programs.

- *Curriculum development* creates instructional programs that are expected to produce the results that have been pledged in securing support for the program.

• *Teacher preparation programs* at preservice, induction, and inservice levels help ensure that teachers are ready to carry out DBAE programs effectively.

• *Assessment practices* document progress and provide feedback to teachers, students, and other audiences, all of whom want to know (and have a stake in finding out) whether or not goals are being achieved.

The most powerful form of advocacy is demonstration of achievement. Therefore, the best way for advocates to create interest in DBAE is to arrange for policy makers to witness programs firsthand. Visits to classrooms where children are discussing and answering intelligent questions about works of art, as well as making art, can be impressive and influential.

If classroom visits are not possible, videotapes are currently available (such as the "Art Education in Action" series produced by the Getty Education Institute for the Arts) that can be used to show DBAE in actual classroom settings. Effective practice is the best testimonial for DBAE. However, advocacy also involves strategic use of time and information: tactics include one-on-one discussions with administrators and policy makers, presentations to school boards and parent groups, and the identification of selected literature that concisely and clearly argues the case for DBAE.

What Do Versions of DBAE Have in Common?

DBAE programs may differ in emphasis (such as promoting one discipline or another as the central or "core" area for inquiry), in types of activities (one classroom might favor field trips to museums because such facilities are conveniently located in the community, whereas others may close the distance gap through multimedia access), and in examples of artworks from different cultures (especially important given the changing student demographics in the United States). Although DBAE curricula may differ in these respects and others, there is a core of basic characteristics that they have in common: a written plan, systematic organization, engagement with works of art, balanced content from the four art disciplines, and developmentally suitable and age-appropriate activities.

A long-range plan and written curriculum allow all of the personnel involved in the teaching of art to take a more protracted view of students' learning and development.

Putting the long-range plan in writing supports continuity, as personnel come and go, and allows teachers to "work on the same page." Such a plan apprises new teachers of what is expected of them as well as what students have previously experienced.

The written curriculum is part of the staff development and support process, in which teachers know what is expected of them and are backed up with ideas, information, and other resources in their engagement with students. The written curriculum also allows teachers to find their way through areas of learning in which their own training might have been modest. The structured written curriculum also reinforces the success of students by ensuring that basic requirements for creating, knowing, understanding, and appreciating art have been set in place.

The written plan might conceivably take one of several forms across a spectrum of needs and circumstances. For example, in a school or district where teachers are experienced with DBAE and wish to implement their own curriculum, a written plan might emphasize general curricular guidelines that are to be followed, leaving it to individual teachers to invent their own educational encounters with art. On the other hand, in a district where more uniform and consistent teaching of art is desired, the written plan might be very detailed, with step-by-step guidance for teachers as well as specific resources provided to support instruction.

Systematic and sequential organization of the curriculum permits teachers rapid access to and awareness of both the written plan and any instructional resources included in it. The structure of the plan provides teachers with a consistent means for accessing the large and potentially complex subject areas of art. It helps ensure that the activities at each grade level are coordinated and sequenced with other grades, so that students might experience up to 12 years of art education, not one year of art education 12 times. For example, a sequential organization and articulation of lessons may reflect a belief in a learning process based on the acquisition of simple concepts before more complex ones. Perhaps students are more likely to be able to perceive, identify, and understand the differences in artists' styles once they have become more familiar with the concept of style itself. This would call for a logical and sequential exposure to relevant and supportive concepts and materials. Or sequence might conceivably be a function of developmental considerations, the structure of the discipline, or the personal interests and choices of the student.

At the same time, recent empirical studies cast doubt on sequential learning as the only way to understand human development. Nonlinear or holistic learning offers a different basis for arranging and selecting curriculum. The general lack of a consensus

around issues of human growth and development, for example, suggests that alternative forms of systemic organization might be embraced by DBAE programs.

Engagement with works of art is indispensable to a DBAE program because the basic motive for learning about art is to further the connection, communication, and satisfaction students can have with works of art. Exactly which works of art can be profitably utilized in a DBAE program is open to significant variance and judgment; the selection of the works of artists from many cultures is emphasized. This is based upon the competence and power embedded in such works and their capacity to elicit inspiration, understanding, and appreciation.

Works of art selected for instruction need to embody clearly the concepts or features for which the works are experienced and studied. There are no restrictions on the study of works of any particular era, place, or culture, although it is expected that for American students the cultural achievements of European and American civilization will receive appropriate attention. It is true that most educators in the United States have not had much contact with a very broad spectrum of works; all teachers need to make a special effort to identify and select images for study that represent cultures that have been neglected by art education in the past.

There are an increasing number of educational resources available, textual and pictorial material on works of art from varied, global cultures. Through professional development, teachers can become familiar not only with the art of their own cultures, but with the art of cultures around the world. In this way the multicultural needs and values of students can be learned, and cross-cultural understanding and respect nurtured.

In addition to multicultural content, DBAE curricula are also arts-pluralistic in drawing upon imagery and ideas from a variety of art sources, including folk arts, ceramics, jewelry, crafts, industrial and applied arts, fashion design, and photography and electronic media, in addition to painting, sculpture, printmaking, and architecture. All of these popular art forms are suitable if selected and employed consistently with DBAE principles.

Many museums now feature exhibitions of photography, industrial design, crafts, and architectural drawings and models. The popular or applied arts also offer exemplars that are likely to be of interest to today's students, such as products designed for young people. Opportunities for connecting with the influences of art in students' lives can also be found in the built, manufactured, and social environments. By treating art as having a very broad horizon in human cultures, DBAE promotes artistic diversity and reinforces the potential of a variety of art forms to carry unique meanings.

Student artworks also have a role to play in the DBAE classroom. They provide

benchmarks for the growth of student knowledge and understanding and the assimilation of skills and techniques. Student artworks play a role in assisting their makers to understand themselves, their world, the ways in which human beings explore and express ideas and feelings, and other large themes such as the power of the natural and built environments. Such works of art may mirror the inspiration and influence of mature works of art that expose young people to varied historical, social, and cultural sources.

Balanced content from the four art disciplines affords students the opportunity to become engaged with works of art from multiple disciplinary perspectives. The amount of time and attention to be devoted to each of the four art disciplines or various combinations of them will depend upon the different forms of DBAE curricula. A work itself in part leads to the determination of the relative importance of each of the disciplines in understanding the work. For example, a nonrepresentational painting might present greater opportunities than a traditional landscape painting for a focus on aesthetic issues concerning abstraction. Determinations are likely to be based on such variables as the student population, instructional resources, and program emphasis. There is no requirement that disciplines receive equal time, that they be sequenced in any particular way, or that certain content within them must always be featured. In fact, as I have noted previously, the disciplines function most effectively when they interweave and reinforce one another, as opposed to when they are encountered as separate fields. In the world of art in which artists, art critics, art historians, and aestheticians function, there is continuous movement back and forth across disciplinary boundaries.

Developmentally suitable and age-appropriate activities need to be selected to maximize student learning; educators must recognize students' appropriate learning and developmental levels. DBAE can be structured in a variety of ways consistent with the considerable body of knowledge that has been acquired by art educators and others about how children grow and learn in the arts. Teachers may adapt DBAE to meet the personal, social, and cultural needs of their students. However, teachers may not always be current on the most recent information available about human development and what is age or grade appropriate. This knowledge can be addressed through continuing professional training and research. In fact, DBAE has shown that young students are capable of far more complex cognitive functioning than most art educators have believed. For example, even very young children can productively explore aesthetic issues in primary grade classrooms where the teacher has been trained in DBAE.

Young students are eager to talk about works of art, even if their vocabularies are limited. They engage with artworks at a level of observation and analysis that can be

Art museums and galleries provide students with opportunities to experience the different perspectives of art. Here, Florida high school students assist the Ringling Museum of Art and photographer Lewis Baltz in developing and installing an exhibit of the photographer's work.

quite striking. Visitors to classrooms where students are talking about art may be surprised at how penetrating children's perceptions and observations about visual imagery can be when their attention is carefully directed and their skills of analysis and response are put into play.

DBAE programs also differ in various ways, including organization of content, forms of professional development, community resources available, and the degree to which art is integrated with other subjects in the school. A review of programs also indicates that people may simply be giving different names to essentially the same things.

DBAE nomenclature is not immutable. Some of the early debates in the field seemed to be more concerned with the name of the process than with the substance underlying it. The evolution of different forms of DBAE requires latitude in nomenclature and avoidance of a rigid set of labels or formulas. Therefore, in some places art-making is called art production, studio art, or creative expression. Art criticism may appear as interpretation and evaluation, or talk about art. Art history is referred to in some

frameworks as cultural heritage, and aesthetics is frequently identified as philosophy of art or even talk about talk about art.

DBAE programs may also show marked variation in their selections of works of art, favoring broad, open criteria. They may draw upon imagery and ideas from a variety of art sources, and make no distinction between "fine arts" and "popular" or "applied arts." Suitable content for study in the four art disciplines may be selected from applied art forms such as ceramics, crafts and folk arts such as costume, textile arts such as weaving, media arts such as photography or video, environmental arts such as earthworks and installations, and contemporary experimental forms such as performance art. These are all resources in addition to painting, sculpture, printmaking, and architecture. The goal is to connect students with experiences in which they encounter a variety of visual images and objects produced by human beings at different times and places for different purposes.

Why Is Administrative Support Essential?
Interest in and support for educational programs in schools rely on a dominolike arrangement: *school boards* want reassurance that parents and the community are behind them when they adopt a policy or promote a particular educational program. *Superintendents*, in turn, want to know that the school board is prepared to support implementation of such programs.

Principals need complete confidence that their superintendents and other district officials (such as curriculum supervisors) are ready to troubleshoot for them when the implementation is carried out. And *teachers* have the expectation that if they invest their professional time and attention, everyone along the line—principal, superintendent, school board, and community—will value what they are pursuing and teaching.

Administrative interest and support is thus indispensable to the planning and implementation of DBAE in schools and districts. For any program to succeed, the people who make it happen must feel that those to whom they are accountable are behind it. Data from the regional institutes, a program in professional development and curriculum implementation initiated by the Getty Education Institute in the second half of the 1980s, suggest that art educators can establish expectations that will be met if they are promoted forcefully and consistently. In one setting, expectations were identified that included creating a school art advisory committee, setting out one- and five-year plans, maintaining an

inventory of community arts resources, and securing the commitment of district administration for future planning and implementation.

Evidence of administrative support can be demonstrated at either school or district level. Of course, the goal is always to bring art education to as many students as possible, guaranteeing equality of curricular opportunity. Therefore, districtwide adoption is the ideal, although it obviously presents greater challenges than securing adoption in a single school or in selected schools.

Programs that exist in only a few classrooms may experience significant difficulties that will hinder their effectiveness. Nevertheless, in very large districts, adoption of a DBAE approach may be more successful in clusters of schools. Or it may be the case, as noted earlier, that some communities prefer to approach adoption and implementation in a more modest fashion, perhaps a school at a time, with districtwide adoption remaining a longer-term goal.

Another key marker of administrative support is that systematic instruction is offered on a regular basis, providing students the time and attention to art essential to a DBAE program. Instructional time should be committed at a level commensurate with the curriculum.

Most curricula will require an average or minimum of several hours of instruction in a school week, but this feature may vary as schools adopt project-based learning or other formats that could materially affect their weekly schedules. In order to succeed, principals, superintendents, and school boards who want their school populations to enjoy the advantages of an art curriculum must set aside adequate time, budget, and other resources for it.

Not surprisingly, when DBAE is perceived in relation to other reform efforts (cooperative learning, higher-order thinking skills, theme-based instruction, multicultural education), it is more successful in garnering administrative and community interest and support. Administrators should support it not as a separate initiative, but as part of an entire package of school change.

The creation of a team within the school, optimally including the principal, art specialist, and general classroom teachers, has proven to be an effective approach to implementing and maintaining a DBAE program. The team members become the leaders, mentors, and motivators in their school, designing a plan, initiating school and district-based staff development, and sharing information about the program with other teachers, district personnel, and people in the community. The team can also look for ways to integrate art across the curriculum.

What Are the Roles of Art Specialists and Classroom Teachers?

A recurring question is, Who should teach art? The best-qualified persons to teach art are the teachers who are competent to use DBAE to enhance student knowledge, understanding, and skills in art. At the middle and secondary levels, where subjects are traditionally taught by specialists, the art teacher usually has the educational background and professional experience to teach art in the most compelling fashion.

The optimum situation, including when classroom teachers are competent in art instruction, is to have art specialists available to provide leadership and resources for curriculum and staff development. It is also worth emphasizing that a school team approach includes professionals other than faculty, such as the principal or (in a district approach) an art curriculum supervisor.

DBAE first developed during the 1980s, when thousands of school districts around the country were experiencing fiscal cutbacks that resulted in the loss of specialized teachers and curriculum supervisors. The numbers of professionally trained art specialists in schools were generally decimated. For example, California lost most of its art specialists and supervisors at the district level.

At the same time, a few other states, such as South Carolina, made new commitments to having specialists available for all of the elementary grades. However, in many states it is unlikely that the situation will change soon, as art and music programs continue to feel the impact of budget cuts. Data from DBAE professional development institutes show that elementary art specialists do not generally lose their jobs when classroom teachers are trained to instruct students in art.

It is a myth that an increase in competence in teaching art by classroom generalists is threatening to art specialists. On the contrary, more specialists have been hired, often because of the requests of classroom teachers, and because there is a renewed sensitivity to the need for the knowledge, skills, and experience of art specialists.

At the elementary level of instruction, the optimal situation is to have the art specialist and classroom teacher collaborate in providing a DBAE program. For those school districts that do have regular classes taught by art specialists at the elementary level, the art program is more likely to become integrated with the general stream of classroom instruction if the classroom teacher, in cooperation with the art specialist,

becomes involved in and more knowledgeable about art and thus is well equipped to reinforce and extend the lessons. It works both ways: art specialists also need to be aware of generalists' concerns so that they can reinforce those colleagues directly. By working together, generalists and specialists can build effective partnerships.

DBAE offers art specialists several professional inducements. First is the chance for them to offer leadership by sharing knowledge and background that is appropriate for a comprehensive art program. This may involve mentoring classroom teachers, museum educators, and others who are interested in the DBAE approach. Second, the art teacher is positioned to eliminate the traditional isolation from other faculty that such professionals have customarily experienced in schools. When art is not taken seriously, neither is the role of the art teacher.

As art and classroom teachers help develop, explain, and demonstrate the contributions of art in general education, the knowledge and competence of both specialists and generalists are more likely to be appreciated and put to productive use. By collaborating in planning and teaching with one another, the art specialist and classroom teacher can pursue thematic and inquiry-based learning that demonstrates to other faculty how art is a model for curricular integration.

In districts where there are no art specialists available, either in the school or in the district, or where there are too few art specialists to service all of the schools in a given region adequately and regularly, the classroom teacher carries the sole responsibility for teaching art and will require commensurate staff development, support, and resources from the school principal and the district in instruction in art.

How Can Discipline Experts Augment Instruction?

Artists, critics, historians, and aestheticians are content resources for art programs. Although they almost always function outside of the school setting, such discipline experts, when available, can provide relevance and immediacy for learning about art. Each has a distinctive contribution to make to the success of discipline-based art education. Art educators may mediate and direct the contributions of artists and other discipline experts for the purposes of art education.

Although each discipline expert represents specific functions in the art community, each is also responsible for demonstrating to students the ways in which all of the disciplines combine to create various levels of art experience. It is critical that students

Teacher preparation programs at preservice, induction, and inservice levels ensure that teachers are ready to carry out DBAE programs effectively.

not see artists, critics, historians, and aestheticians only as one-dimensional specialists. For example, in considering what goes into the creation of a work of art, artists can describe the variety of conceptual and visual sources and activities that are part of the artistic process, reflecting the integrated, overlapping character of the art disciplines.

Artists draw from the disciplines of criticism, history, and aesthetics as part of their process, as practitioners in each of those fields draw from one another. There is a simultaneous blending of observations and insights about image and meaning, their location within a cultural context and milieu, and their basic nature. Artists do not ordinarily and consciously separate the distinctive contributions of the different disciplines, yet they are constantly affected by them all in understanding art and in creating their own work. Artists from different traditions and cultures should be brought into a DBAE program.

By sharing conceptual tools, materials, and methods of inquiry used in their respective disciplines, the artist, critic, historian, and aesthetician can help students to

understand the mature practitioner's outlook and experience. For example, continuing with our example of the artist (it could be any one of the four discipline experts), by reflecting on, demonstrating, and talking about the process of artistry, from conception through design to execution, to how the work is displayed or how it functions, artists can encourage students to appreciate the planning and deliberation that goes into the making of new works and the thoughtfulness and care with which mature artists approach their creative efforts.

Artists can also demonstrate the tools and techniques they use to create various types of imagery and to produce desired visual effects, and how to expand and utilize the possibilities of various materials and media in art-making. Artists can also teach about sensitivity to the materials; the importance of patience, persistence, and other personal qualities to the creative process; and how elements of experimentation, exploration, and risk may be involved in the evolution of artists' ideas and works.

Artists can also underscore the importance of evaluating their own work, learning to evaluate the work of others, and using the feedback to make revisions and changes that will strengthen their own artistry. Of course, evaluation is also conducted in various ways by the public, by art patrons, by museum and gallery curators, and by art critics.

Art critics, art historians, and aestheticians can also serve as specific and first-hand content resources. Each discipline contributes knowledge, skills, and understandings concomitant with the functions and tasks of that discipline, as described earlier and by analogue in the above example of the artist. Such individuals are most likely to be found on college or university campuses, but museums will certainly have curators on staff, and larger city newspapers usually have a critic or even several of them to write reviews about visual art, films, and the performing arts. These individuals might be invited to talk about what they do in their professional work as discipline experts, and perhaps take students through the exercise of applying the criteria they use when reviewing a work of art.

Although the purpose of DBAE is not to make students into professionals in these areas, drawing on the functions and expertise of a primary practitioner in each art discipline is a valuable means of eliciting and emphasizing content. For example, each of the four foundational disciplines has a distinctive vocabulary. Contact and discussion with practitioners can help students understand how such terminology facilitates the disciplinary perspective. Therefore, a DBAE program seeks opportunities for students to have contact with and learn from those who actually do art criticism, art history, and aesthetics, as well as those who make art. In addition, there are other people in the community

who are not art discipline experts but who do engage in activities that are related to art. These include, for example, anthropologists, cultural historians, collectors, and folklorists who may be sources of information and support.

What Are the Contributions of Museum Educators?

The museum educator also functions in the real world of art. In recent years, many museums have increased their educational programs for school groups. Incorporating DBAE into these programs can enhance their effectiveness and help ensure that museum field trips, which require considerable effort and may be costly to arrange, are productive educational experiences. Museum educators may be attracted to DBAE because of its focus on objects of art, because of the discussion it involves, and because it goes beyond the art studio.

Museum educators and docents have much to offer, and their participation in student museum visits is enhanced by planning and coordination. Working with teachers, they can formulate inquiry-based tours that replace "canned" varieties and help students to have more active experiences with works of art. For example, some museum educators create games or puzzles that stimulate students to search for clues and solutions in works of art in different galleries.

Some institutions have responded to schools' needs for field trips to museums by creating materials for previsit orientation, including texts, slide shows, and videotapes. A visit to the classroom in advance by a museum educator or a docent helps students become familiar with what they might expect to see and experience. A postvisit discussion also helps to reinforce the experience and highlights connections between the visit and the students' classroom study.

Without such linking activities in place, the full value of the museum experience is unlikely to be realized. The field trip becomes a "one-shot deal." Research (and common sense) clearly supports the value of preparation and follow-up. Why visit a museum unless the experience can be successfully connected to the art and general classroom curriculum?

Because frequently students have their first museum experiences with a school group, the importance of orientation and introduction cannot be overestimated. The museum educator can explain what a museum is, how it decides what to acquire and preserve for exhibition, what goes on behind the scenes to preserve works of art and prepare

them for installation, how museums differ from one another, and what kinds of information one can learn from and experience in museums. When the museum educator is working dynamically, interacting with students, questioning replaces didactic presentation.

In the museum, museum educators help visitors to have successful experiences with works of art. To do so, they employ various educational aids, including labels and wall signage, gallery tours, audio- and videotapes, printed materials, and interactive media. To plan a successful school visit, the museum educator needs to know the students' ages and class levels, experience with art, and cultural backgrounds, as well as what concepts or themes the teacher is trying to reinforce through the visit. The museum educator, working with the teacher, can plan the museum experience in a way that reflects sensitivity to these issues.

Museum educators help students feel comfortable in museums so that they will want to come back on their own with their families and as part of their lifelong learning in art. Parents might coordinate with the teacher's program so that the questions students ask and the qualities of works to which they attend adequately reflect the broad array of interests explored back in the classroom. Teachers in schools can also learn from museum educators' experience with outreach how to extend the learnings.

PERFORMANCE ASSESSMENT

Why Is Student Achievement the Bottom Line?
The increasing competence of students in creating, understanding, and appreciating art through teaching and learning is the goal for DBAE. Therefore, evaluation of student achievement must be an integral part of the program. Results provide important feedback to teachers and administrators about the adequacy of instruction, as well as feedback to curriculum designers and developers about the effectiveness of the program.

There has been a tradition in art education of resisting standardized testing (inappropriate to the nature of art, too time-consuming, and so on) that seeks to quantify student competence in art. Most art educators have preferred instead to use more qualitative and subjective measures to assess students' artworks. For example, the *studio portfolio* approach requires the teacher and student to make qualitative judgments about improvements in the student's efforts over time, including art products and written and

analytic work. In determining what might be revealed by examination of student-produced artworks, the teacher can take into consideration the form and content in these works as well as the student's ability to handle technical tasks with art materials. This approach to assessment places a premium on the student's own work as an ultimate measure of achievement in the course of study.

A comprehensive approach to art, in contrast, provides the student with the opportunity to perform and achieve in art in a number of ways, not only in the creation of art. Therefore, the studio portfolio approach may not answer the question, How should an instructor assess student understanding and appreciation of art?

Some programs answer this question by featuring more comprehensive *student process portfolios*. This performance record comprises more than only art products; it also draws from the exercises and other learning activities that the student undertakes to find solutions to various problems presented in art criticism, art history, and aesthetics. Such a portfolio may include (a) written materials that address ideas and information from the historical, critical, and aesthetic disciplines; (b) personal assessments of individual works and progress perceived over time; and (c) video and audio assessments of students talking and discussing their works. Although the traditional portfolio was often limited to a student's own artworks, even these now contain written analyses and reflections by the student.

In one staff development institute, the portfolio assessment process uses students' previous creative work as the basis for subsequent assignments. Thus a high degree of integration between instruction and assessment is built into the feedback loop. Several non-DBAE programs, like Harvard's Project Zero's ARTSPROPEL, include essays, diaries, and research projects that make the student portfolio an assessment resource not only for art but also for writing, evaluation of teaching, and other purposes.

Unlike other subject areas in the school curriculum, there are no widely published or canonical techniques or instruments for performance assessment in art. This is due in part to the lack of a strong tradition of assessment, at least below the college level, in the disciplines of studio art, art history, art criticism, and aesthetics. In addition, although individual researchers have devised limited assessment techniques and instruments in connection with their graduate or professional investigations, no one has yet created a comprehensive system of assessment that addresses all areas of learning and performance.

However, an important recent development is the conduct of the National Assessment of Educational Progress (NAEP) in Art, the first in several decades. It is a government-

sponsored assessment to determine students' knowledge and understanding in art. For example, NAEP will ascertain if students have acquired a vocabulary for talking and writing about art in the course of making critical judgments. Together with the national standards in art, the NAEP will give art educators, for the first time, student data and baselines in art across states, regions, and nationally.

Both NAEP and the national standards support the aspiration that by the end of this century there should be at least a rudimentary national system in place for tracking and strengthening student achievement in art. In the meantime, the need to determine exactly what students are learning in their art programs, to build the credibility of art education in the eyes of administrators, school board members, and parents, has led to the development (again, principally in regional institutes for professional development) of assessment measures as a necessary feature of such programs.

Commercial curricula, for example, all include attention to assessment, typically in the form of a section within each lesson unit. The formats include discussion questions (suitable for all disciplines), comparison and contrast (with slides or other reproductions), written essays, and portfolios.

One especially vexing challenge for assessment of art learning is the longitudinal judgment of student work over some period of time, perhaps a year or more. If art education is to address the long-term growth of students' knowledge, understanding, and creativity in art over grades K–12, some form of process portfolio record must be developed to communicate change and achievement to teachers and students alike. Another limitation is that numerical scores may reveal relative performance compared to other students on a standardized test, but until baselines are established for students of given grade levels and experience with DBAE, such scores will have limited meaning. In the meantime, art educators must continue to devise ways of assessing student achievement that will provide indications of progress.

How Can Teacher Effectiveness Be Determined?

Performance assessment of the quality of instruction must look beyond student achievement to ensure also that the teacher is accomplishing the goals set for delivery of the program. Because DBAE is a comprehensive approach in which many (or perhaps most) teachers have not necessarily had professional preparation, it is necessary that preservice and inservice professional development

be included as essential elements in implementation of the curriculum. Assessment of teacher performance is a measure of the adequacy of staff development and provides feedback to both teachers and program supervisors or administrators.

Assessment of teacher competence and effectiveness is an issue in American education that has received considerable attention in the reform of teaching and teacher education. Some states now require teacher examinations for both new and continuing teachers. The accountability movement of the 1970s and 1980s affected credentialing programs and utilized procedures such as peer review, classroom observation, and paper-and-pencil measures of basic skills and knowledge to determine the adequacy of teacher competence and instruction.

One very promising development, paralleling the adoption of national standards for the subject areas and the imminent focus of the NAEP, is found in the activities of the National Board for Professional Teacher Standards (NBPTS). These standards are also products of the educational reform climate of the 1990s.

NBPTS offers guidance and direction to the states and school districts in their certification of currently credentialed and practicing teachers as well as those to be hired in schools in future years. An examination of both the teacher standards and the tests should suggest an affinity for DBAE, given that high expectations exist in both for teachers who will be providing comprehensive instruction to their students. However, it will be necessary to develop tests that do not concentrate predominantly on one discipline or another, so as to assess progress on all of the standards promulgated.

The NBPTS long-range goals are to improve the climate for teaching and learning by increasing the supply of high-quality entrants to the teaching profession, with an emphasis on minorities, and to improve teacher education and continuing professional development. The board certification standards in subject areas are based on five principles:

- Teachers are committed to students and their learning.

- Teachers know the subjects they teach and how to teach those subjects.

- Teachers are responsible for managing and monitoring student learning.

- Teachers think systematically about their practice and learn from experience.

- Teachers are members of learning communities.

NBPTS addresses the need to validate the teaching skills of the millions of men and women entrusted with K–12 education. It does so by looking at specific knowledge and understanding that national task forces, composed of teachers and discipline experts, have agreed instructors ought to possess and that are essential to competent and effective teaching. A group working under the direction of NBPTS devised and published in 1995 an outline of such standards for art. These constitute a baseline against which teachers in art education programs might be assessed.

In addition to the NBPTS, research and development by the regional institutes sponsored by the Getty Education Institute have provided a context for thinking about assessment of teacher effectiveness. For example, increasing evidence of collaboration (not just cooperation) among members of DBAE teams suggests that colleagues can offer one another constructive feedback. However, peers obviously need to be familiar with the subject being taught. An art specialist who is teaching a DBAE program should not be assessed by an art specialist who is not familiar with DBAE, or by a non-art specialist. This same principle may be said to be true for other professionals, such as education curators in museums.

Also, when classroom teachers are assessed in general, that assessment ought to include art instruction as well as other subjects. Principals can encourage classroom instructors to value art by taking the time and effort to observe the teaching of art units as part of that evaluation process.

In addition, research on peer observation and assessment in general education has provided other measures focusing upon the use of inquiry skills and upon classroom management in connection with instruction that might be adapted to the art classroom. Some of these have been developed in connection with specific curricula in other subject areas. There are no models that have been designed and widely disseminated for art, but it is possible to adapt certain questions to the art program:

- Is the instructor exhibiting and conveying high interest and enthusiasm for the subject of art?

- Are opportunities offered for students to focus on works of art that exist in their own communities and to which they have ready access, such as public monuments or buildings?

- Is the instructor asking questions that help students elicit the meanings within

works of art, not just memorize the purposes and functions of art? Are the questions likely to lead to the students' asking questions, as well as searching for answers?

- Can students see the relationships between the meanings of the artwork and the curriculum content they are studying?

- Is the teacher's use of works of art in museum visits or of reproductions in the classroom well integrated with the students' studio work and used to inspire and demonstrate the ideas that are the focus of the unit?

- Are students guided in understanding why artistic styles have varied in different times and cultures, or are they only taught to label artworks using style names?

Self-report is another tool for evaluating teacher competence that has been used with success in various DBAE demonstration projects. The strengthening and improvement of teachers' attitudes toward art influences the motivation, energy, and follow-up that go into instruction. The sense of self-growth and interest of teachers, who also have the potential to be learners, are supportive indicators of the preparation, delivery, and commitment to instruction in art that may be expected as a consequence of effective staff development. Indeed, one of the most striking findings of DBAE teacher assessments across the country is the excitement and enthusiasm generated in school faculties and in museum education departments by the approach. Teachers are eager to become students themselves and to establish or renew a continuing relationship with the larger world of art, for their own sakes as well as those of their students.

What Does Overall Program Evaluation Reveal?

A third level of assessment in DBAE is that of program evaluation, which relates both to the subject of art and to the larger goals of schooling. Beyond the assessment of individual student achievement and teacher effectiveness, what has been accomplished by the effort as a whole? Are the program goals being accomplished? How are the program components working

together? How does DBAE contribute to the more general outcomes promulgated in the school for all subject areas?

Such a level of assessment would be especially appropriate for educational policy makers, such as school boards, which are concerned about program outcomes and how such results fit into the larger picture. How can that feedback be used to improve the overall program in a school and in a school district? Following up on such inquiries will assist the DBAE team in determining what is needed to strengthen the program and to achieve desired goals. Questions to be asked by program evaluators at the school and district levels might include the following:

- Is there regular and systematic instruction in art in the school and in the district by certified instructors and school teams trained in DBAE?

- Is the program consistent with the national standards in art, state framework, district guidelines, and graduation requirements?

- Is the content of the program organized and provided in a sequential written format for the teachers' use?

- Is the content of the program balanced with knowledge, skills, and inquiry processes from each of the four art disciplines?

- Are the learning activities in classrooms varied and appropriate to the disciplines and the goals for student learning? Does the program offer opportunities for the integration of art and other subject areas?

- Are there sufficient instructional resources (facilities, equipment, materials, time, budget) to support the program?

- Is the use of works of art balanced and integrated, with representation from a diverse array of cultures, periods, and art forms?

- Are opportunities for museum and gallery visits provided? Is there pre- and postvisit planning between teachers and museum educators?

- Are community resources such as artists, art reviewers for local newspapers, art historians at the local college, and others who have something to impart (such as the librarian) brought into classrooms or visited in their work settings to assist with instruction?

- Are there opportunities for teachers to receive additional inservice experiences, either within the school or district or in higher-education settings?

- Do the teachers assess student performance? If so, how are those data utilized? Are teachers' performance and effectiveness also assessed? If so, how do these relate to the national teaching standards for art?

- Are school administrators and school board members supportive of the program? Have they declared by policy statement or adoption of goals their commitment to it?

- Is there a sense of fulfillment, achievement, and satisfaction among the program participants? What are the perceived unmet needs?

More than 100 professional development and curriculum implementation summer institutes in the Getty Education Institute-sponsored regional program have been evaluated over the past eight years, and certain findings are now in view, including the following, which are elaborated in Brent Wilson's *The Quiet Evolution* (1997):

- Change initiatives such as DBAE are more likely to succeed when they are systemic. Therefore, reform in art education needs to be seen in the larger picture of educational and school reform. Multiple reform initiatives can reinforce one another.

- Professional development and curriculum planning need to be pursued simultaneously. DBAE poses substantive instructional goals for teachers who usually have not had the professional preparation requisite to a quality, comprehensive education in art. Therefore, development of new curricula is meaningless unless teachers are comfortable with the content and prepared to use the materials.

- Assessment of the program at various levels must be part of the overall planning, and feedback from such activities should be utilized to correct and strengthen the implementation of DBAE. Regular formative assessment can help ensure that goals and objectives are being addressed.

- Ongoing communication and collaboration at many levels are necessary to sustain an emerging and growing quality education in art. Teachers, discipline experts, administrators, museum educators, and others must function as a team in order to carry out change of the magnitude implied by DBAE.

- Museums and other community institutions that are part of the art world enrich and enhance DBAE learning, and inclusion of them is an indispensable part of the approach. The centrality of works of art mandates that students encounter high-quality examples of such objects on a regular basis.

- When DBAE is taught as part of a thematic unit in which art plays a significant role, it attains a less isolated position in the curriculum. But themes are only one approach to curriculum organization.

- Knowledge and skills are not ends in themselves, but rather the means for under-standing human purpose and for creating new visions of it. The focus on the four art disciplines is not intended to make students into disciplinary practitioners, but to enable them to utilize the content and inquiry processes of the disciplines as means of addressing larger questions of personal and societal meaning (this might be described as a general goal of art).

- Continuing assistance is needed to sustain DBAE programs in schools, including such resources as professional development institutes and workshops, renewal programs, model instructional units, newsletters and e-mail networks, expert consultants, and mentors.

Resources

4

PROGRAM CHOICES

What Basic Program Resources Are Needed?

By virtue of its flexibility and openness to the varying conditions in local schools and school districts, DBAE does not prescribe a fixed set of instructional resources and technologies that must be in place. Rather, instructional resources must be carefully and deliberately selected with such variables in mind as the demographics of the student population, students' ages and grade levels, access to cultural and community resources, technical support, and budget.

It is possible, however, to stipulate the kinds of instructional resources and categories of supportive materials that may enhance and enrich the art experience for students. A considerable amount of experience with teachers and students over the past 10 years in the regional institutes for professional development and curriculum implementation has demonstrated that DBAE programs may evolve with very different resources, reflecting local needs, traditions, and circumstances (geographic, fiscal, and so on). Categories of instructional resources featured in programs might include the following:

- *Units of study* derived from commercial products (such as the Multicultural Art Print Series) or developed in the professional development setting, school or district, and that provide content in the four art disciplines. Such units may prescribe broad themes or precise and focused topics, motivating activities, background reading, writing and discussion exercises, the creation of artistic products, technology interfaces, and an assessment component.

- *Instructional support material* produced by publishers and commercial firms, such as children's books, instructional kits, and reproductions of works of art such as the Multicultural Art Print Series.

- *Works of art* in local museums, galleries, cultural centers, private homes, and public places. Objects of industrial design can be brought from the students' own homes. City halls, post offices, banks, and business centers often feature large-scale public sculpture or textiles. Printed reproductions, slides, videotapes, and computer-accessed image banks and data sources all provide access to images of works of art when it is not feasible for students to encounter works firsthand.

- *Films and videos* about artists, artistic movements and schools, tools and techniques, social and cultural contexts, and other art-related areas. For example, the National Gallery in Washington, D.C., produces excellent and relatively inexpensive videos about the lives of artists and various historic and stylistic movements. Local libraries and video rental stores may be sources for art-related documentaries.

- *Artists, art critics, art historians, and aestheticians* who can visit classrooms (perhaps even be "resident" in them) or be visited in their own working settings in the community. Artists often share studio space, and it may be possible to see the work of several artists in a single visit. Some communities have "open studio" days when artists permit visitors to see their works and workplaces. Art critics might be found at metropolitan newspapers or television stations, and art historians are usually employed in universities and museums. Aestheticians might be the most difficult to locate, as they usually are headquartered in philosophy departments in relatively large universities.

- *Information* about artists, stylistic movements, and art world issues is available in books, magazines, newspapers, and computer databases. These might be found in local libraries or in school district resource centers where DBAE is established. Information on artists and their works from around the world is also available in reviews and reports appearing in national magazines that have regular sections on the arts, in television stories, and increasingly through high technology. ArtsEdNet (see Chapter 5) provides access to many networks of information and ideas in the arts.

- *Artistic tools and materials* with which students can have firsthand contact and experience with the making of art objects. Classroom demonstrations and activities will be limited by the facilities and means that are present. DBAE looks for a variety of hands-on creative work with two- and three-dimensional media.

- *Professional expertise* in the form of personnel with professional preparation in DBAE instruction and backup assistance in the form of consultants, curriculum supervision, and staff development. This includes not only art educators but other types of experts as well whose contributions are important. For example, the

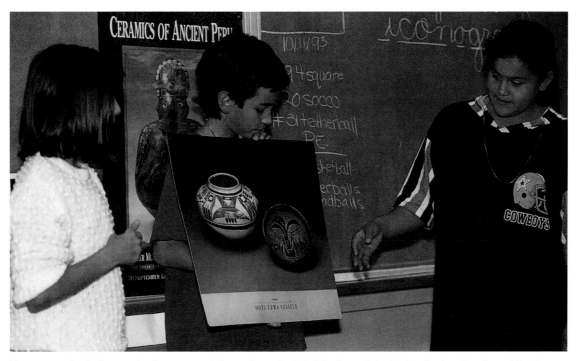

Resources include curriculum materials such as the Multicultural Art Print Series developed by the Getty Education Institute.

development of computer-assisted instruction and growing access to art-relevant software suggests that persons with computer know-how will be increasingly called upon to help with programs in which such resources are being utilized. Ultimately, the teacher is central to the success of the program. To achieve full and rich implementation, teachers should have a command of DBAE approaches. Because many art specialists and classroom teachers may not have had such professional preparation, the school or district can help build competence through inservice staff development. The availability of trained art specialists, art curriculum supervisors, and other experts can significantly strengthen a program.

- *Evaluation resources* that support ongoing monitoring, assessment, and analysis of student achievement, teacher effectiveness, and overall program outcomes. These help build credibility in a DBAE program. Without an assessment of the components of DBAE, educators have no assurance of what has been learned by students and how well the program is working. Evaluation helps demonstrate that students do achieve, provides teachers with feedback that helps them improve their instruction, and reassures the principal and school board that the allocation of valuable resources is justified.

• *Technological resources*, important tools for helping teachers and students realize effective instruction. Such tools can be used (a) to access information about art, (b) to create works of art, and (c) to communicate with others about art. ArtsEdNet, an electronic network for art educators sponsored by the Getty Education Institute for the Arts and accessed through the Internet, features many written curricula and educational materials.

Should Schools Use Commercial or "Homemade" Curricula?

As more and more school districts across the country have adopted or expressed interest in DBAE, the development of curriculum materials and instructional resources has intensified both locally and commercially. The result is a range of options from which school districts may choose when building art education programs. In general, school districts have the flexibility to use published educational materials or those of their own devising as long as such materials are consistent with district or state guidelines.

Because a majority of the states and an increasing number of the 16,000 school districts in the United States have adopted comprehensive approaches to art, there are a number of versions of curricula on the commercial market that offer written, sequential instruction based on content from various art disciplines. These commercial products include reproductions of works of art, biographical material on artists, historical background on art movements, and other resources.

The main advantage of a *commercially produced curriculum* is that it provides a ready-made program that can be adopted in and adapted to a large number of schools and classrooms. However, commercial curricula are most commonly used to support the local curriculum. Especially when art specialists are available to offer regular instruction in art, commercial materials are likely to be used in a supplementary fashion.

Possible disadvantages of relying entirely upon a curriculum produced by a publisher or educational materials manufacturer include the following: (a) it may not provide examples of works of art that relate to the local or regional museums or demographic circumstances, (b) it may not adequately address all of the four art disciplines, (c) it may not be sufficiently compatible with the state or local district framework or the tenets of DBAE, and (d) it may not offer teachers a sense of ownership of the material that comes

from having produced it in a local effort. The cost of obtaining published materials and stocking school classrooms also must be taken into account.

There are several advantages to using a *locally produced curriculum*, created by a team of art specialists and curriculum developers organized within a district, region, or even state. First, such a curriculum allows the users to determine at the outset the scope and sequence of the art program. Second, it facilitates the creation of units of study based on works of art that may be locally available and on cultural choices that reflect the local student demographics. Local design and development of art curriculum is usually considerably less expensive for the schools involved than it would be to buy a commercially produced curriculum, although the cost of release time for curriculum and staff development can add up when considered over the years it may take to establish a program successfully.

In any case, visual materials need to be purchased to support instruction. The disadvantages of this path are that although a locally produced curriculum may cost less, the investment of time and money required can be considerable (the process may take several years), and most districts lack the facilities and resources to produce and publish high-grade materials (although desktop publishing makes it increasingly easier to create such materials locally).

An alternative is to blend the approaches—that is, modify a published program to create a customized curriculum. This might be the most practical option for many districts. The scope and sequence of the curriculum, its learning objectives, and selected individual lessons could be used. Additional learning activities can be written by a curriculum development team.

Commercial products, reproductions of artworks, and other instructional materials should be reviewed and selected to supplement the curriculum. This offers the advantage of creating ownership of the curriculum by the teachers who will use it, while at the same time utilizing an increasing number of excellent support materials that are on the commercial market, including slides, videos, and posters of artworks.

Throughout the United States, individuals and groups of art educators are engaged in producing new curricula. One of the most effective ways for educators to learn about what has been accomplished and what is available is to attend the national conferences of the National Art Education Association and meetings of state art education organizations to hear about and view new ideas and products. Art specialists, curriculum developers, teacher educators, and students frequently use such forums as opportunities to

display their curriculum materials and obtain professional reactions. Commercial vendors usually display their products at such meetings. Magazines such as *Art Education, Arts & Activities,* and *School Arts* also offer information to educators about new curricula and demonstration projects.

The Getty Education Institute, which does not produce or endorse any specific commercial curriculum, completed an experiment in curriculum development in 1990 known as the Curriculum Development Institute (CDI). Teams of art specialists, art supervisors, and museum educators from several states prepared model units of instruction to illustrate several different DBAE approaches. Intended to be used as reference material and illustrations for others who wish to develop DBAE curricula, they are available in *Discipline-Based Art Education: A Curriculum Sampler* (1991). Finally, there have been dozens of units of study created in the regional institute program. Each of the institutes has developed units with local or regional flavor.

How Is Pluralism in Art and Curriculum Choice Supported? DBAE curricula are pluralistic in that they draw upon imagery and ideas from a variety of art sources, including folk arts, ceramics, jewelry, crafts, industrial and applied arts, fashion design, photography, and electronic media, in addition to painting, sculpture, printmaking, and architecture, and from a variety of cultures. All of these popular art forms are suitable if selected and employed consistently with DBAE principles (as elucidated in Chapter 3).

In response to the demand for multicultural instructional materials, several of the regional institutes have developed programs with cooperating museums to produce sets of multicultural prints. The initial effort in this direction, a cooperative venture of the Getty Education Institute with Crystal Productions and the J. Paul Getty Museum, introduced in 1991, resulted in the first set in the Multicultural Art Print Series, a group of poster-size, full-color, laminated reproductions of artworks for use by teachers. These broaden the exposure of students to the variety of cultures contributing to the American mainstream.

Many of the commercial curricula available offer schools and districts ready-made resources to establish some version of a DBAE program. Typically, curriculum materials on the market, which vary in structure and detail, possess pluralistic features, although examples of works from world cultures may be uneven in quality and scope. For a long

Today there are an increasing number of excellent resources available for teaching a comprehensive approach to art.

time, it was difficult for teachers to obtain slides or printed reproductions of anything other than European or American artworks. Now, however, there are increasing numbers of resources for nontraditional and diverse world art. Books, videos, and electronic sources for art imagery representative of a wide spectrum of national cultures are becoming more widely available. Some defects in commercial materials have been remedied in updated versions from the publishers.

Ultimately, only commercial publishers are likely to have the resources to produce such educational materials to support programs throughout the country for millions of students in thousands of schools. Purchasers of commercial curricula should evaluate these products carefully, however. Each should be reviewed for its respective strengths and weaknesses. Some examples of curricula that might be examined include *Art in Action* (Holt, Rinehart & Winston), *Art Works* (Holt, Rinehart & Winston), *Adventures in Art* (Davis Publications), and *SPECTRA: Learning to Look & Create* (Glencoe Publications).

In addition to these products, which include full-scale lessons and supporting materials, manufacturers also publish posters, books, slides, and video- and audiotapes

about art and artists for use in the classroom. These materials, such as *Art Talk, Art in Focus*, and the publications of *Scholastic Magazine*, help support the integration of art criticism, art history, and aesthetics with art-making.

COMMUNITY RESOURCES

What Do Museums and Community Arts Organizations Contribute?

Museums are community institutions that are primary resources for seeing and studying original works of art. The quality and access to educational services provided by art museums vary significantly across the country. Compared with many small institutions, larger museums, especially those located in urban centers, tend to have more comprehensive collections and can give more attention to educational services such as publications, tours, and programs for schoolchildren and teachers (who can reach more students than museums usually do). There are many exceptions, however; some of the finest museums and museum education programs in existence are located away from major centers of population and commerce.

To be sure, art is to be seen in many places besides museums. It exists in galleries, in private homes, in libraries and cultural centers, and in a variety of public places (historic sites, civic centers, public murals, parks, and so on). In fact, artifacts exist everywhere, as in the architecture of our communities and in the industrially designed consumer products we have in our homes. Although museums and galleries may furnish more opportunities for the viewing of "fine art," the sheer variety of potential art sites provides every teacher an abundance of examples from which to draw.

Additional resources are community arts organizations that run programs in cultural centers, schools, city halls and courthouses, community centers, and street fairs. Community-based art organizations sometimes spring up and compensate for the lack of adequate art programs in schools. Although their interest has been largely centered on art-making, these efforts (such as the Marwen Program in Chicago and the Alvarado Art Project in San Francisco) have accomplished a range of outcomes, including cultivating student awareness of public art (such as murals on buildings and civic sculpture), introducing youngsters to art from around the world (museums are widely used by such after-school or weekend programs), and providing contact with artists. These are all

possible building blocks. Information about these resources, as well as community art events, can be found listed in local newspapers and magazines that feature cultural calendars, critical reviews, and background stories on artists and exhibitions.

In addition, larger communities often have arts councils that represent official or public responsibility for promoting and supporting the arts. These may develop in response to infrastructure at the state or regional level, which in turn is part of a national network of arts councils linked to the National Endowment for the Arts, the federal agency established in 1965 "to encourage and support American art and artists."

Parents, school board members, and community art activists should educate and lobby legislators and other policy makers to support state and local arts councils and encourage their initiatives in art education. The parents are also voters who can call upon members of Congress to support and strengthen the NEA and its activities in art education.

What Roles Can Parents and Policy Makers Play?

Parents can exercise enormous influence on school programs. Educational reform and site-based management have demonstrated the power of parents to affect the curricular priorities, staffing, and resource allocations of schools. It is essential that educators enlist the support of parents and develop their understanding about the benefits of DBAE for their children's general education. Through the National PTA and other support groups, parents may become more involved in school programs.

Specifically, parents can provide support by advocating comprehensive art education in which their children experience and learn about various facets of art. This can be accomplished through meetings, presentations, newsletters, and word of mouth. In a partnership project with the National PTA, the Getty Education Institute has developed a chapter meeting kit that includes such materials for advocacy as brochures and videotapes that can be used by interested PTA chapters throughout the United States (see the bibliography). The materials explain the benefits of a comprehensive art education program and why such a program should be part of every school's required course of study.

Parents have much at stake in decisions about what ought to be included in the general curriculum. They know that their children need higher-order thinking skills,

cultural understanding in an increasingly diverse society, and the development of competence and confidence through the building of inquiry skills. The rationale for DBAE is predicated upon meeting such needs.

Parents need to be encouraged and enabled to carry this message to their school boards, and to the larger community, through advocacy and media attention directed to demonstration projects. Parents also serve on school boards, whose interest and support can obviously be critical to the adoption and successful implementation of DBAE. Parents can facilitate, reinforce, and extend their children's art education by taking them to art museums, galleries, and art centers; by acquiring and encouraging learning about art through books, television programs, videotapes, and computer-accessed resources; and by supporting their children's art-making activities.

Finally, school board support is critical to the establishment and maintenance of a comprehensive art education program. District policy is formulated by the local board. Administrators and teachers closely observe and refer to what is valued by board pronouncements and decisions. Supportive statements and actions regarding the contributions of art, such as a list of goals, can help reinforce support among those who are accountable, including superintendents, principals, curriculum supervisors, and faculty.

The Getty Education Institute works in partnership with the National School Boards Association, National Association of Chief State School Officers, and other professional organizations to find ways to help school boards and community policy makers learn more about the benefits of art education for students.

What Opportunities Exist for School-to-Work Linkages?

A third community resource is found in the internships and potential career opportunities furnished by school-to-work linkages, or the effort to create a better bridge between students' experiences in school and their experiences in the work community. This requires an educational program that teaches secondary school students basic skills while at the same time offering them the chance to employ those skills in apprenticeship and internship settings.

Of course, most students will not necessarily pursue professional careers in the arts, but for those who do have ambitions to build a livelihood around art, there ought to be ample opportunities for school-to-work linkages to be developed prior to more specialized training in art school.

School-to-work opportunities also acknowledge the reality that only about half of graduating high school students in the United States actually go on to college; millions of other students seek employment and start work careers right out of high school. For example, with regard to art-making, students learn about artists of many kinds as they access works of art of diverse varieties. Therefore, they have the opportunity to become familiar with such art-related career possibilities as painter, sculptor, architect, magazine illustrator, product designer, and computer graphic designer. Students can learn about the real issues of work and career that individuals in such roles face daily.

A list of art-related occupations would be very long, and these occupations touch many aspects of people's lives. Increasing numbers of students are also likely to be drawn to information-age careers that will focus on information, education, and entertainment. Here, too, visual literacy will be valued, and the art lesson will be a source in school programs for students to experience and learn visual-related skills and understanding.

There are also benefits for the workplace beyond the professions of art. Most employers seek to hire people who are good problem solvers, have respect for their work, are attentive to detail even while keeping the bigger picture in view, and know how to communicate effectively. These by-products of a comprehensive education in art can serve students well in the general world of work after their school years and formal art education.

PROFESSIONAL DEVELOPMENT

Why Is Preservice Preparation Important?

The engine driving the DBAE program is a balanced and integrated curriculum drawing its content from the four art disciplines, but the engineer who drives the train is the teacher. Without competent instruction, the best written materials or instructional resources are unlikely to be used effectively. No art program can be implemented well without good teaching. Therefore, it is critical to the implementation of a DBAE program that teachers, whether art specialists, general classroom teachers, or both, be adequately prepared.

As part of the movement in art education toward comprehensive programs in art, many states have adopted new guidelines for teacher credentialing. This has paralleled the establishment of secondary-level graduation requirements in art for a growing number of

states. A majority of the states now require at least one course in visual art or the arts for high school graduation. This requirement is leading to the upgrading of teacher education requirements and, one hopes, the programs in the credentialing institutions.

Preservice preparation in art education traditionally includes a focus on personal and creative development in art, primarily through art-making. To meet the needs of a new generation of teachers, such programs should also include, at a minimum, study of the theory and practice of DBAE and the contributing art disciplines. For the classroom teacher this may be presented in the form of a comprehensive course.

Preferably, however, such preservice would include additional contact and methods courses to build greater sophistication and competence. A group of credentialing institutions met at Snowbird, Utah, to discuss their different approaches to preservice. The proceedings of that meeting and of the Sunbird Conference held in Long Beach, California, at which campuses of the California State University reported on preservice programs, are available from the Getty Education Institute (see the bibliography).

In some institutions, future teachers may be permitted or required to choose a separate focus on the art disciplines. They may select an introductory course in studio art, a survey course in art history, or a course in aesthetics in the philosophy department. The important point is that preservice classroom teachers and art specialists must have the opportunity to acquire background and experience with all the disciplines of art and how these can be integrated in instruction.

There are several major university programs in art education that now provide significant course work in the art disciplines as a standard requirement for teacher credential students; such programs are in existence at the Ohio State University and the Pennsylvania State University. It has been amply demonstrated in the regional institutes that more comprehensive preservice education in the art disciplines would be a substantial asset for implementing quality art education programs. In fact, the close collaborations of the institutes and their nearby and regional teacher credentialing institutions have affected teacher training in those places and others.

The extent of this preparation will always be affected by the teacher's interests and life experience, the support for art in state and school district guidelines, the requirements of the credential program, and the time and resources available for exposure and involvement with art as part of teacher education. Although some teachers are highly motivated and continue to strengthen themselves professionally through self-study, the majority of teachers are more likely to feel hard-pressed to keep up with current developments. Somewhere along the line, they may miss opportunities to reinforce their

teaching repertoires and skills. Therefore, schools and districts that want their staff members to have at their command all of the necessary resources to facilitate good teaching in art have a strong self-interest in providing professional development opportunities on a regular basis.

How Has Professional Development Evolved?

Inservice professional development, in the actual school setting and through summer professional development opportunities, is also important for several reasons, primarily because so many teacher education programs typically provide only a cursory introduction to aesthetics, art criticism, and art history.

Art specialists, general classroom teachers, and principals who work together on a school team need professional development to understand the theoretical basis of DBAE and how it is translated into instructional practice. In addition, one of the most common findings of demonstration and pilot projects is that inservice must be continuous, with teachers constantly returning to reinforce and build their knowledge, skills, and understanding.

In some settings, the development of thematic units in which art plays a significant role may help address the problem of curricular overload, where too many subject areas are competing for too little time. Such inservice opportunities are equally important for principals who monitor, evaluate, and support art education programs, and for art specialists whose education and teaching focus has traditionally emphasized studio art.

Many districts have found as well that involving curriculum supervisors and other central administration personnel in such experiences can elicit greater support and understanding of the districts' programs. Planners of inservice programs can consider a variety of options, including the following:

- After-school and weekend workshops, with teachers being compensated by the school district for the investment of their personal time.

- Professional development opportunities ranging from day-long sessions during the school year to several weeks during the summer. These might be extended over the years in "renewal" sessions, in which teachers acquire greater levels of proficiency in DBAE in order to help their own colleagues also become compe-

tent through a "trainer of trainers" model. Professional development efforts in the regional institutes and art teacher seminars are examples of such training.

- Extension and continuing education courses at a local college or university where preservice instruction is offered or where teachers can select introductory or more specialized course work in the foundational art disciplines.

- Teacher self-study and building of knowledge base, skills, and understanding through reading about art, visiting museums and taking advantage of their education programs, going to galleries, and working with art materials.

- Dedicated in-school professional development time routinely expected of teachers—for example, certain hours after the students' school day but within the teachers' working day as defined in their contract.

One of the most significant resources for professional development in discipline-based art education has been the establishment over the past decade of several regional institutes for DBAE research and development throughout the country. These projects, with the encouragement and support of the Getty Education Institute and other public and private funders, are important not only because of the thousands of schools and teachers (and ultimately hundreds of thousands of students) who have been affected by their programs. The regional institutes have also demonstrated that DBAE is not a monolithic theory, promoting any one individual form of curriculum and instruction in art. Working within the frameworks provided by national standards, individual state guidelines, and local needs and circumstances, the institute model has become a major resource for professional development throughout the nation.

The regional institutes have been responsible for nurturing different forms of DBAE, thus expanding the approach and drawing in art educators who were skeptical about the initial characterization of DBAE in the early and middle 1980s. That was a groundbreaking formulation represented largely by the Getty Education Institute's Los Angeles Institute for Educators on the Visual Arts, led by Dwaine Greer, which ran from 1983 to 1990. Over those seven years, many important lessons were learned about DBAE theory and how to mount an effective professional development and curriculum implementation program. The Getty Education Institute, which had initially conceived of the regional institute program as an opportunity to spread the impact and outcomes of the Institute in

Los Angeles, encouraged the development of variation and idiosyncrasy in the conception of DBAE and its implementation through professional development. The hope has been that DBAE will flourish under regional and local influences, needs, and circumstances.

Consortia were necessarily developed to implement DBAE because of the complexity and magnitude of the task, which is an unprecedented wholesale makeover of art education in American schools. Consortium components have included

- advisory boards, staff, institute faculty members and facilitators, discipline consultants, advisers, and evaluators;

- schools and school districts, and college and university departments of art, education, and art education;

- local school boards and county and state departments of education;

- art museums, art centers, libraries, and historical societies;

- professional education and art education organizations, and state and local arts agencies and councils; and

- charitable foundations and other funders.

The six original regional institutes included the Florida Institute for Art Education at Florida State University at Tallahassee; the Minnesota DBAE Consortium at the University of Minnesota; Prairie Visions: The Nebraska Consortium for DBAE at the Nebraska State Department of Education; the Ohio Partnership for the Visual Arts at Ohio State University, Columbus; the Southeast Institute for Education in the Visual Arts at the University of Tennessee at Chattanooga; and the North Texas Institute for Educators on the Visual Arts at the University of North Texas at Denton. A seventh institute, developed from summer institutes, was established in 1994 and now operates in Fresno, Los Angeles, and Sacramento. Elsewhere in the United States, summer programs and school-year workshops also developed (with and without the Getty Education Institute's financial assistance), such as the Kutztown Project in Pennsylvania and the South Carolina Summer DBAE Institute.

Seminars for art specialists have also been created in Illinois, Michigan, New Jersey, and Ohio. The Getty Education Institute assists the networking of its own consortia

and other professional development programs through conferences, publications, and other forms of technical help.

The most significant outcomes for each of the regional institute programs have been the local and regional responses and the changes that have occurred in the process of establishing DBAE programs in different geographic locales. These professional development consortia (because each institute is itself a locus for dozens of participating school districts, teacher training colleges, museums, and art organizations) have taken the lead role in demonstrating the varying forms DBAE might assume. This variety has occurred with no sacrifice of basic principles. Indeed, the regional institutes have led the way in transforming theory into exemplary practice.

This volume is not the place for a thorough exposition of each of the regional institutes and consortia, all of which have interesting and productive histories. In *The Quiet Evolution* (1997), Brent Wilson, who has been evaluating the programs since 1988, provides extensive detail about the development and contributions of the institutes individually and as a group; they are acknowledged here for the central role they have played in the evolution of DBAE.

What Are the Resources in the Literature of Art Education?
The theories and practices of discipline-based art education have evolved through individual investigation, dissertation- and thesis-directed research, presentations and dialogues at professional seminars and conferences, model programs and demonstration projects, and exchanges of concepts and ideas in the professional literature. That literature provides constructive assistance for those seeking to understand the DBAE approach more fully. The literature may be summarized as falling into four categories: theoretical, research, curricular, and historical.

Theoretical writings on DBAE advance concepts and ideas in an effort to build a platform or systematic set of principles for the approach. Such literature develops support for a coherent system by indicating theoretical precedents in art education and related fields and by offering reasoned and persuasive arguments. Theoretical writing often involves the exploration of conceptual boundaries, intellectual problem solving, and speculation concerning possible variations. An example of theory making is the philosophical literature, which offers rationales for the role of art in education.

Research literature reports on studies that have employed scientific methods to set forth hypotheses and subject them to tests to be affirmed or rejected. These studies, typically associated with professorial and graduate study in art education, psychology, child development, and related fields, may provide verification of theoretical tenets of DBAE or create new theory on the basis of experimental results.

The four art disciplines in relation to education suggest many inquiries suitable for empirical investigation. For example, what sequence of art ideas is most effective for helping students acquire and master the language they need to share their responses to works of art? What are the appropriate concepts from the theory of child development that have impacts on this issue? How do children of varying cultural backgrounds learn, and how can different learning styles be addressed?

Curricular literature involves the translation of philosophical platforms or sets of ideas about teaching DBAE into applications: objectives, lessons, support materials, and procedures for evaluation. This literature may be found in art education textbooks, materials published by commercial manufacturers, and curriculum guides obtained from local districts that have developed their own versions of DBAE. Word processing programs and desktop publishing have simplified the production of textual materials on a local level. There are many periodical articles and reports made at state and national conferences that describe model programs and demonstrations of DBAE curricula in school settings.

Historical literature traces the development of the theory and practice of discipline-based art education. Such literature helps clarify the sources of ideas and the ways in which specific theories and practices have had impacts on the development of DBAE. This type of literature helps art educators understand where it came from and where it is headed, what individuals and institutions have contributed to its evolution, and the relationship of DBAE to other historical themes and crosscurrents in the field of art education.

Information on selected literature and other resources concerned with discipline-based art education is provided in the annotated bibliography of this volume. The materials listed include books, professional journal articles, and monographs; conference proceedings and reports; curriculum and instructional materials; videotapes; and dissertations. Electronic technologies and the Internet have improved access to all of these resources. Several organizations have played major roles in the development of this professional literature:

- *The National Art Education Association* (NAEA), publisher of *Art Education, Studies in*

Art Education, and many monographs on specialized topics, has functioned for half a century as a primary disseminator of the literature of the field. NAEA meetings throughout the 1980s and 1990s have been key venues for the dialogue about DBAE. The NAEA, through its advocacy and liaison, helps extend that dialogue to other organizations that have similar and related interests, such as the American Council for the Arts and the National Endowment for the Arts.

- *The Getty Education Institute for the Arts* has been involved in sponsoring the development of DBAE literature since DBAE's inception in 1981, and many of this institute's publications appear in the bibliography. These include monographs such as those published in the Occasional Paper Series, conference reports and proceedings, special issues or sections in professional periodicals, book series such as that published by the University of Illinois Press, videotapes, and curriculum materials, such as art reproductions published in partnership with Crystal Productions.

- *The Adjunct Clearinghouse for Art Education* at Indiana University in Bloomington, a branch of the ERIC system, lists in its computer-accessed system a wide variety of literature about comprehensive art education. This includes papers commissioned for professional meetings, reports on research related to DBAE, specialized topical literature such as that on evaluation, and statistical and demographic data.

- *University Microfilms* in Ann Arbor, Michigan, is the repository for theses completed for master's degrees and dissertations completed for doctoral degrees in this country. *Dissertation Abstracts International* catalogs and lists studies prepared by graduate students seeking their professional degrees in art education and other fields. The major areas and issues of the theses and dissertations cataloged are mentioned in 100-word synopses; these abstracts allow efficient search of the data source for DBAE topics.

Access to the professional literature is useful to many people involved with DBAE. For example:

- *Advocates* can use DBAE literature and prepared presentation materials to provide

philosophical or theoretical rationales for a quality art education program in deliberations and negotiations with administrators and educational policy makers, which can lay the groundwork for adoption of DBAE.

- *Program planners*, such as curriculum supervisors and teachers, can draw from the literature of DBAE specific concepts for implementation, curriculum, instructional support, and evaluation. Although school districts vary in many ways, they also have much in common, and the information and ideas contained in the literature can save time and prevent redundant development efforts.

- *Teacher educators* at both the preservice and inservice levels can make use of the literature to implement, reinforce, and amplify their instruction. The literature's concise and lucid explanations of the rationales and theories supporting DBAE can help teachers to understand more clearly what such programs seek to accomplish.

Evidence exists that teachers prefer to be intellectually connected to DBAE, rather than simply carrying out a recipe or implementing an approach they do not understand or appreciate. The "Art Education in Action" videos produced by the Getty Education Institute translate printed text into words and images that demonstrate how effective teaching takes place in the classroom.

5

The Future of DBAE

Who Is Responsible for Developing DBAE?

A key question in the elaboration of a theory or educational approach is that of ownership: Whose thinking and ideas are to be recognized, codified, and adopted? Is DBAE being formulated by a few influential professors, curriculum theorists, and textbook publishers? Or will the thousands of other potential participants (most prominently classroom teachers, principals, and art specialists) have the opportunity to provide their input and help to shape DBAE?

One of the most important developments in discipline-based art education has been the emergence of a variety of forms of the approach. These alternative forms are often based on differing conceptions of art, of art's contribution to general education, of the nature and use of the four foundational disciplines, and of curriculum design and implementation; they may also be based on a host of other factors.

One cause of this proliferation of variation was the establishment in the 1980s and 1990s of various professional development programs, which often go into high gear during the summer months, that have all created somewhat different versions for their various constituencies—that is, art specialists, classroom teachers, artists, museum docents, curriculum supervisors, principals, superintendents, and parents from hundreds of school districts in at least half a dozen regions of the country. Each of these programs has spawned other programs and helped facilitate the spread of staff development in DBAE.

All of these training programs were developed in response to the finding that teachers are usually unable to provide content in and implement inquiry processes drawn from the four art disciplines without substantial preservice and inservice training. Although the goal of the Getty Education Institute for the Arts was to create a prototype for staff development, a national model that could be replicated and adapted locally, the fact is that many advocates and programs were not and are not sponsored by the Getty Education Institute. School districts, teacher training programs, and museums in many places have developed their own programs.

Why Is DBAE, Like Art Itself, Necessarily Open-Ended?

With the benefit of hindsight, we can now see that the initial conceptions of DBAE, which sought to define a

uniform set of characteristics, and which were articulated in the professional journals and in pilot projects like the Los Angeles Institute for Educators on the Visual Arts from the early 1980s, were preliminary formulations. In fact, as subsequent research and development projects like the regional institutes have demonstrated, the many differences in basic assumptions held by theorists and practitioners almost ensured that different forms of DBAE would emerge.

This open-ended quality or latitude for variation actually mirrors a basic conception of art that is prominent in aesthetics. As stated earlier, art is an open, value-laden concept, and its changing nature makes it difficult to create strict boundaries or parameters for it. The boundaries of art expand or contract in light of new concepts, new forms, and new challenges to old definitions.

Furthermore, argument in aesthetics is valued as a means of advancing clear criteria for smart choices. In order to say what is art, the best we may be able to do is to compare new candidates to familiar cases thoughtfully and then make intelligent and informed decisions about which to adopt. The same applies to the various interpretations and implementations of DBAE.

The avoidance of rigid definitions or of a closed system (beyond several general common characteristics, indicated earlier) ensures a certain structural openness and fluidity. This is appropriate and consistent with the ever-changing face of art, as one's conception directly affects one's views on how art is created, how it is encountered and understood by audiences, how it is taught in schools, and how it is otherwise valued and utilized in society.

Each of the foundational art disciplines—art-making, art criticism, art history, and aesthetics—itself exists within a context of changing values, interpretations, and meanings. Thus the impact on art criticism and art history of diverse perspectives is accommodated and finds its place in DBAE, which does not depend upon a narrow definition of art, on any one of the four disciplines, or on any particular strategy employed for implementation so long as it is ethically and intellectually defensible. For example, in some settings adoption by the entire school district works well, whereas in others it has been more effective for a few schools within a district to pioneer the approach and then work to bring in the others at a later time. Furthermore, much of the debate in the journals and at conferences has not been about the "what" of DBAE (basic values and goals of a comprehensive approach to art), but rather about how to implement it (the best processes and use of resources to establish some form of the scheme).

What Is the Role of New Ideologies?

Another factor driving the evolving character of DBAE is the proliferation of intellectual, social, and cultural currents toward the end of the twentieth century. These have affected virtually every discipline and field of educational interest and endeavor. New systems, theories, trends, and symbols are finding their way into the dialogue (and the imagery) of each field in a variety of ways. It is therefore reasonable to expect that DBAE will continue to evolve.

Innovation and variation will add to the growing catalog of choices and resources available from which educators can select and implement quality art education programs. Indeed, it is clear from the evaluation reports on the most enduring programs (in place for about 10 years at this point) that each of them has been transformed and adapted to such contingencies as the changing climate of educational reform, demographic shifts among students and communities, and the findings of new research about human development.

INTERDISCIPLINARY STUDY

Why Is Integration of Subject Fields a Priority?

American schools have traditionally responded to pressures for creating and implementing new curricular areas by rearranging time schedules or simply squeezing one more slice out of an already highly divided pie. Throughout the last half century, schools have taken on additional agendas (often not related to the academic curriculum), such as educating students about drugs and AIDS, promoting environmental protection, teaching teenagers to drive, and exploring family life and sex education.

The demands on educators' time and other instructional resources have generally elicited one of two kinds of responses: enormous frustration and resentment at the ever-expanding menu of school responsibilities, with a concomitant grudging acceptance of the assignment leading to minimal professional investment; or a sense of stimulation and provocation, sometimes resulting in the implementation of such coping strategies as ingenious scheduling schemes, pursuit of project-based learning, and team teaching. For example, the current trend identified as "Copernican" scheduling provides longer but

fewer discrete periods in the school day, which facilitates team teaching and project-based learning.

But perhaps the most significant reaction to the piling up of subjects in the school day, and the accompanying sense of increasing fragmentation in the curriculum, has been the effort to integrate fields of study. By identifying the mutual interests of subject areas and exploring such curricular devices as thematic units, educators have amplified their opportunities for cooperation, collaboration, and consolidation. Such changes may even have enabled some teachers to end up with additional time for their subject areas within the context of integrated or interdisciplinary study.

An example of integrated or interdisciplinary curriculum at the secondary school level is the humanities program, which offers a broad platform for inquiry into different facets of civilization. The interdisciplinary lens may lead to the search for knowledge, understanding, and skill in such diverse disciplines as architecture, social thought, biography, and theater, without actually providing separate time in the school day for each of those subject areas. In art, discipline-based art education offers the ready-made fusion of four art disciplines, each of which has its own integrity but all of which in combination can provide a unified experience for students.

How Does DBAE Facilitate Interdisciplinary Studies?

Art may be taught effectively through an interdisciplinary or thematic approach because of DBAE's nature, which draws on multiple perspectives. For example, in presenting a lesson about the American artist John Singleton Copley, the teacher might simultaneously examine the painter's command of technique and respect for the paint medium that made Copley the most outstanding portraitist in colonial America and the difficulty an eighteenth-century painter had in finding a community of other artists, scholars, or critics to interpret and evaluate his work. The teacher might further help students to explore the cultural milieu that encouraged Copley to marry into the aristocracy so that he might move comfortably and professionally among his patrons and sitters, his resistance of the temptation to edit while still pleasing the sitter with an empirical realism that was true to his concept of the nature of art, and the capacity of portraits to occasion aesthetically interesting experiences.

Art provides a core to interdisciplinary studies. Works such as *Field of Corn with Osage Oranges* by Malcolm Cochran in Columbus, Ohio, give educators many opportunities to integrate science, the arts, and other subject areas.

In order to compose a lesson drawn around these aspects of John Singleton Copley, a teacher would have to become familiar with the life and work of the artist. But such integration of background knowledge, drawn from various art disciplines, can result in much more than a unified lesson experience in art. It may also provide the access points, openings, and leads that can help create a theme linking art to other subject areas and to larger themes. The Copley example suggests connections with and curricular possibilities involving American history, biography, geography, social thought, and politics.

A nontraditional example of art and curricular integration, drawn from an indigenous American culture, might be learning about Hopi Indian baskets, which are woven out of the corn plants that also provide food and spiritual sustenance in the Native American tradition. Corn provides more than the reeds that are crafted by Hopi artisans into baskets, masks, and other objects. Corn is a sacred food, and the Hopi are its caretakers. The colors of the corn plant, embedded in the baskets, have symbolic and specific values.

The seasonal growth cycle of the corn is interwoven with the lives of the people, as in the basket, so that the interrelatedness of nature and spiritual values is illuminated. The basket serves as a bridge to history, culture, and sociopolitical systems. Also, the study of Hopi basketry offers the teacher abundant opportunities for integration with language arts, reading the texts, singing the songs, and sharing the prayers of the Hopi society. The disciplines of anthropology, ecology, sociology, and women's studies might all furnish additional background for the use of Hopi baskets in a DBAE program. A film like Patricia Ferrero's *Hopi: Songs of the Fourth World* (1983) puts the simple basket into the complex context of a thousand-year-old tradition.

Disciplinary integration in art is educationally desirable not only because it represents the actual ways in which artists and other arts-related professionals experience art, but because it is an effective way to underscore and reinforce what is important. In the examples just cited, it is difficult to imagine really understanding the artwork that Copley painted or the baskets woven by the Hopi without examining the social and cultural features of their respective environments, the values that animated members of their respective societies, and the motivations and interests of the art-makers themselves.

Furthermore, the critic, historian, and aesthetician may all view these same works, but they are likely to have different observations to make about them, depending upon the way they experience the works—yet all return to the same sources. By focusing upon significant examples of art that are capable of being experienced and assimilated in multiple ways, educators can convey that the richness of art is more than the sum of its parts. In all of these efforts, teachers should underline the fact that art is a distinctive way of human knowing, with a history of accomplishment and special problems of understanding and appreciation.

In pursuit of new models of curricular integration and thematic or interdisciplinary study, the College Board and the Getty Education Institute are cosponsoring a national program: The Role of the Arts in Unifying the High School Curriculum. Five very different sites have been selected in the states of Maryland, Massachusetts, New Mexico, Texas, and Washington for the five-year project, which supports local teachers in marshaling ideas and other resources for an integrated approach to secondary curriculum in which the arts play a central role. It is expected that five different models will emerge, and these will be widely shared for use by other schools around the country. Already some other schools are moving ahead with plans similar to those embraced by the College Board and Getty Education Institute project, the theoretical antecedents of which are spelled out in a publication by Bruce Boston titled *Connections* (1996).

What About the Performing Arts? The

concept of a discipline-based approach to the performing arts of music, theater, and dance has grown from the discipline-based model in visual art advanced by the Getty Education Institute. The establishment and funding of discipline-based professional development and curricular implementation institutes in music and theater, to complement the visual art institute at the Southeast Center for Education in the Arts by funders other than the Getty Education Institute, demonstrates interest in DBAE beyond the visual arts.

Additionally, eight satellite institutes have been established in music and theater, as well as a partnership with the South Carolina Center for Dance Education. National conferences on discipline-based theater and music education have been held, as well as presentations made at meetings of the Music Educators National Conference, American Association for Theater Education, and other performing arts education organizations. As currently formulated, the discipline-based approach advanced by these institutes is a conceptual framework that expands teaching and learning in the arts beyond production (in the visual arts) and performance (in the performing arts) to include aesthetics, history, and criticism.

The development and implementation of discipline-based conceptual frameworks in music, theater, and dance, as well as discipline-based units of study in these areas, reveal growing interest among schools, and particularly among principals in schools, who view a discipline-based approach across the arts as a prudent and efficient use of limited professional development resources and classroom teacher time.

A VISION OF SUCCESS

What Constitute "Best Practices" in the Classroom and School? A vision of

success eventually must be translated into best practices. The following lists summarize from earlier chapters, DBAE theory, and the findings and experience of the regional institutes program some key elements of best practices in a discipline-based approach to art education.

Students in DBAE classrooms

* have teachers who are trained in discipline-based art education;

- are active inquirers;

- are able to interpret works studied by researching, discussing, and writing about them, and by creating their own works;

- ask questions when confronted with works of art;

- develop criteria that allow them to make informed judgments about artworks studied;

- understand the roles of art in current and past civilizations as they relate to self and others, society, and other cultures;

- express ideas through art by creating works alone and with others;

- are informed audience members;

- use technology to communicate about art, access information about artworks, and create works of art;

- have access to reference materials and other resources for study;

- are provided opportunities to visit museums and other community art resources;

- document their learning and progress in art;

- understand the roles of art as they relate to possible career opportunities; and

- are supported by teachers, administrators, and parents who value art as a basic part of students' education.

Teachers in DBAE classrooms

- are committed to teaching art as a substantive subject in which there are knowledge and skills to be acquired;

- are able to select and use appropriate works of art for study;

- can facilitate student inquiry, interpretation, discussion, and writing about works of art as well as the creation of student artworks;

- engage in rich art experiences;

- have access to basic historical and interpretive information about works selected for study;

- adapt, arrange, and create discipline-based curriculum units of study and instructional support materials;

- are committed to collaborating with other staff and mentoring when appropriate;

- identify and use community art resources;

- use technology to communicate about art, access information about works, and facilitate students' creation of artworks;

- document and assess student learning;

- integrate art into the curriculum;

- participate in long-range planning for incorporating art in the classroom and the school;

- are committed to their own professional development in art education; and

- communicate the importance of art education to fellow teachers, administrators, parents, and others in the community.

Principals in DBAE schools

- are committed to art as part of a basic education for all students;

- serve as the instructional leaders in art education for their schools;

- dentify and secure the necessary human and material resources to implement DBAE;

- are committed to documenting and assessing student learning;

- participate in and support the long-range planning process and provide teacher planning time for it;

- are committed to using and funding community art resources in implementing discipline-based art education;

- are committed to using technology to communicate about art, access information about works, and facilitate students' creation of artworks;

- are committed to their own professional development in art education as well as to that of their teaching staff; and

- communicate the importance of art education to fellow administrators, parents, school board members, and community members.

DBAE schools

- are willing to adopt the principles of discipline-based art education;

- are committed to implementing discipline-based art education;

- use rigorous written and sequential curricula in art based on long-range planning for DBAE programs;

- provide the necessary human and material resources to implement discipline-based programs;

- use community art resources to support and enrich DBAE;

- have committed faculty trained in DBAE;

- are committed to professional development in DBAE for new teaching staff and ongoing professional development for other staff;

- have principals who are members of their schools' teams in art education;

- are willing to set rigorous standards for student achievement in art;

- are willing to document and assess student achievement in art;

- use technology and seek to upgrade the information tools available for further inquiry and experience;

- network with other schools and communities to support DBAE;

- have completed a vision process, self-assessment, five-year long-range plans, and annual priorities to guide program development; and

- if necessary, secure additional financial and technical support to implement DBAE.

What Is the Promise of Electronic Technologies for the Future?

The electronic age is beginning to unfold a new world of computer-assisted programs and communication resources that can be enlisted by teachers of art, including hypercard stacks, laser discs, and virtual reality (computer-simulated 3-dimensional environments). The first artists used burned wood and vegetable roots to make art on cave walls 30,000 years ago; today, increasing numbers of artists are exploring computer-based image making, laser art, and digitized film and video. Art educators also have increasing access, as information systems "go electronic," to technology that puts innumerable instructional resources at the user's fingertips.

In the past few years, the Internet has become an enormous new resource for

teaching and learning. It already connects millions of users in the United States and around the world. Over time, it will develop further in ways that will benefit art education. Individual teachers, school teams, curriculum development groups, and professional development settings will be linked globally. They will have increasing capacity to access the resources of museums, libraries, universities, commercial publishers and manufacturers, professional organizations, and other networks of art professionals.

Several universities, such as Ohio State, pioneered development of curricula for computer-assisted imagery beginning in the 1970s. Art educators in those programs and elsewhere have explored the potential of electronic resources for the teaching as well as the creation of art. Today teachers of virtually all subjects are aware of the potential of computer technologies. The growing importance of visual literacy has provided a special opportunity for art curricula, especially when they involve the use of the newer systems.

In the field of art education, ArtsEdNet (http://www.artsednet.getty.edu) provides, via the Internet, instant access to information that can serve the needs of K–12 art educators and general classroom teachers, as well as academics, community advocates, and educational policy makers. This electronic on-line service offers a variety of materials that can be used in art education, such as art images and curriculum frameworks; a 24-hour, year-round on-line conference center where colleagues can collaborate or learn about new developments; and a gateway between arts educators and tens of millions of Internet users. The gateway feature connects users to arts education-oriented sites such as ArtsEdge (a collaboration of the Kennedy Center and the National Endowment for the Arts), ArtsUSA (American Council for the Arts), ERIC (Educational Resources Information Center), and the Getty Education Institute for the Arts.

Over time, other electronic home pages and Web sites will develop on the Internet and further serve to connect teachers with the resources, text and image alike, that they require. Extraordinary access, for example, to museum images, architectural views, and art objects from all over the world (both past and present) will soon be downloaded by teachers for their classrooms, replacing the familiar delays associated with requesting films or slide sets to be sent from the library or district office.

One of the most important consequences of information-age technology is likely to be a reduction in the sense of isolation that has often been felt by teachers, especially those in art, who often find themselves working very much alone in their classrooms without much professional connection, guidance, or support. The Internet connects individuals, wherever they live and work, to the entire world, creating a true "global village." For example, ArtsEdNet features an e-mail chat group that offers individuals opportunities

The Internet has become an enormous resource for teaching and learning, providing access to information that can serve the needs of K–12 art educators and general classroom teachers.

to connect informally and share ideas and information with large numbers of colleagues spread throughout the nation and the world. Teachers are now able to communicate easily and inexpensively to share information from points distant and to exchange and give wide dissemination to new and useful curricular approaches and resources.

What Are the Aspirations for DBAE?

As American education continues to transform and the twenty-first century beckons, those who are committed to art as an important human endeavor and experience will continue to work to strengthen art education in schools, museums, homes, and community settings. Over the past decade or so, the debate in the professional field of art educators has been intense, with no one person or concept

dominating the debate. But one idea has emerged that continues to draw new adherents, and that enjoys increasing support not only within the art education professional community but among other educational and arts-oriented communities as well.

Discipline-based or comprehensive art education represents the coming of age and maturation of art education in American schools. Though still evolving, and subject to the growing pains attendant to any new system or approach, DBAE has made significant strides in the 1980s and 1990s toward achieving the more significant role for art in schooling for which so many of its practitioners have always hoped.

As art moves from the margins to a more central role in the curriculum in the minds of educational leaders and policy makers, the struggle continues to secure time, personnel, and resources to support the full contributions of art in the curriculum. But the prospects seem better now than at any time in the history of art education in this country that art, the former remote cousin in the curriculum, can move from the periphery toward the center and assume its rightful role as a full member of the educational program in schools. It is necessary to sustain this momentum and acquire new and ongoing support from the teachers, administrators, and parents whose interest and commitment are indispensable to implementation. The case must continue to be made through aggressive advocacy that art education addresses general educational goals of schooling, such as the development of thinking skills, the ability to communicate and respond in an increasingly complex culture, and an understanding of diversity in a rapidly changing world.

Visual arts and the DBAE approach can help mediate efforts to educate generations of students who are knowledgeable about their world, possess skills for successful living, are attuned to the rich artistic values of their cultures and others, and can encounter life with zest and imagination.

Supporters of discipline-based art education have a mission: to transform art education and schools so that the life-enhancing benefits of the visual arts can be made available to everyone. In the current climate of educational reform, there are tremendous opportunities to demonstrate the truth of the claims made for art within the covers of this book and in numerous other writings about art education.

DBAE offers the vision that someday the limitless power of art to sustain human life and help all of us better experience the human condition will be a commonplace feature of schooling.

Bibliography

Compiled by Ralph A. Smith

References consist of a selection from an annotated bibliography that can be found on ArtsEdNet, the Getty Education Institute's on-line information service. Books and items treated as books (e.g., pamphlets, special issues of journals) are listed separately, except in the case of the category "Instructional Resources," which subsumes books, articles, and other kinds of pedagogical materials. References to writings in reports and proceedings are treated as articles. Items date from 1982 and address DBAE specifically or matters in some way related to it.

Books

Addiss, Stephen, and Mary Erickson. *Art History and Education*. Urbana: University of Illinois Press, 1993. Introduction by Ralph A. Smith. A volume in the series Disciplines in Art Education: Contexts of Understanding.

American Association of Museums. *Museums for a New Century*. Washington, D.C.: American Association of Museums, 1984.

American Association of Museums. *Excellence and Equity: Education and the Public Dimension of Museums*. Washington, D.C.: American Association of Museums, 1992.

Armstrong, Carmen. *Designing Assessment in Art*. Reston, Va.: National Art Education Association, 1994.

Arnheim, Rudolf. *Thoughts on Art Education*. Occasional Paper 2. Los Angeles: Getty Center for Education in the Arts, 1989

Bakewell, Elizabeth, William O. Beeman, and Carol McMichael Reese. General editor, Marilyn Schmitt. *Object, Image, Inquiry: The Art Historian at Work*. Santa Monica, Calif.: J. Paul Getty Trust, 1988.

Barrett, Terry. *Criticizing Art: Understanding the Contemporary*. Mountain View, Calif.: Mayfield, 1994.

Boston, Bruce O. *Connections: The Arts and the Integration of the High School Curriculum*. New York: College Board, 1996.

Boughton, Doug, Elliot W. Eisner, and Johan Ligtvoet, eds. *Evaluating and Assessing the Visual Arts in Education: International Perspectives*. New York: Teachers College Press, 1996.

Broudy, Harry S. *The Role of Imagery in Learning*. Occasional Paper 1. Los Angeles: Getty Center for Education in the Arts, 1987.

Broudy, Harry S. *Enlightened Cherishing: An Essay on Aesthetic Education*. Urbana: University of Illinois Press, 1994. New preface. First published 1972.

Brown, Maurice, and Diana Korzenik. *Art Making and Education*. Urbana: University of Illinois Press, 1993. A volume in the series Disciplines in Art Education: Contexts of Understanding.

Burton, Judith, Arlene Lederman, and Peter London, eds. *Beyond DBAE: The Case for Multiple Visions of Art Education*. North Dartmouth: Art Education Department, Southeastern Massachusetts University, 1988.

Chalmers, Graeme F. *Celebrating Pluralism: Art, Education, and Cultural Diversity*. Occasional Paper 5. Los Angeles: Getty Education Institute for the Arts, 1996.

Chapman, Laura H. *Instant Art, Instant Culture: The Unspoken Policy for American Schools*. New York: Teachers College Press, 1982.

Clark, Gilbert A. *Examining Discipline-Based Art Education as a Curriculum Construct*. ERIC:ART. Bloomington: Social Studies Development Center, Indiana University, 1991.

Consortium of National Art Education Associations. *National Standards for the Arts: What Every Young American Should Know and Be Able to Do in the Arts*. Reston, Va.: Music Educators National Conference, 1994.

Cromer, Jim. *History, Theory, and Practice of Art Criticism in Art Education*. Reston, Va.: National Art Education Association, 1990.

Csikszentmihalyi, Mihaly, and Rick E. Robinson. *The Art of Seeing: An Interpretation of the Aesthetic Encounter*. Santa Monica, Calif.: Getty Center for Education in the Arts, 1990.

Dobbs, Stephen Mark. *Perceptions of Discipline-Based Art Education and the Getty Center for Education in the Arts*. Santa Monica, Calif.: Getty Center for Education in the Arts, 1988. Also ERIC Document Reproduction Service ED388599, 1988.

Dobbs, Stephen Mark, ed. *Research Readings for Discipline-Based Art Education: A Journey beyond Creating*. Reston, Va.: National Art Education Association, 1988.

Eisner, Elliot W. *The Role of Discipline-Based Art Education in America's Schools*. Los Angeles: Getty Center for Education in the Arts, n.d. Reprinted under the same title in *Art Education* 40, no. 5 (1987):6–26, 44–45.

Ewens, Thomas, ed. *Discipline in Art Education: An Interdisciplinary Symposium*. Providence: Rhode Island School of Design, 1986.

Feldman, Edmund B. *The Artist*. Englewood Cliffs, N.J.: Prentice Hall, 1982.

Feldman, Edmund B. *Practical Art Criticism*. Englewood Cliffs, N.J.: Prentice Hall, 1993.

Fitzpatrick, Virginia L. *Art History: A Contextual Inquiry Course*. Reston, Va.: National Art Education Association, 1992.

Gardner, Howard. *Frames of Mind: The Theory of Multiple Intelligences*. New York: Basic Books, 1983.

Gardner, Howard. *Art Education and Human Development*. Occasional Paper 3. Los Angeles: Getty Center for Education in the Arts, 1990.

Gardner, Howard, and David Perkins, eds. *Art, Mind, and Education: Research from Project Zero*. Urbana: University of Illinois Press, 1989. First published as a special issue of the *Journal of Aesthetic Education* 22, no. 1 (1988).

Getty Center for Education in the Arts. *Beyond Creating: The Place for Art in America's Schools*. Los Angeles: Getty Center for Education in the Arts, 1985.

Journal of Aesthetic Education 19, no. 2 (1985). Special Issue: Art Museums and Education.

Journal of Multi-cultural and Cross-cultural Research in Art Education 6, no. 1 (1988). Special issue on DBAE.

Kleinbauer, W. Eugene, ed. *Modern Perspectives in Western Art History: An Anthology of Twentieth-Century Writings on the Visual Arts*. Toronto: University of Toronto Press, 1989.

Kaelin, E. F. *An Aesthetics for Art Educators*. New York: Teachers College Press, 1989.

Lankford, Louis. *Aesthetics: Issues and Inquiry*. Reston, Va.: National Art Education Association, 1992.

Levi, Albert William, and Ralph A. Smith. *Art Education: A Critical Necessity*. Urbana: University of Illinois Press, 1991. A volume in the series Disciplines in Art Education: Contexts of Understanding.

Mitchell, Ruth, ed. *Measuring Up to the Challenge: What Standards and Assessment Can Do for Art Education*. New York: American Council for the Arts, 1994.

Moody, William J., ed. *Artistic Intelligences: Implications for Education*. New York: Teachers College Press, 1993.

Moore, Ronald, ed. *Aesthetics for Young People*. Reston, Va.: National Art Education Association, 1995.

Parsons, Michael J. *How We Understand Art: A Cognitive Developmental Account of Aesthetic Experience*. New York: Cambridge University Press, 1987.

Parsons, Michael J., and H. Gene Blocker. *Aesthetics and Education*. Urbana: University of Illinois Press, 1993.

Perkins, David N. *The Intelligent Eye: Learning to Think by Looking at Art*. Occasional Paper 4. Los Angeles: Getty Center for Education in the Arts, 1994.

Smith, Ralph A., ed. *Discipline-Based Art Education: Origins, Meaning, Development*. Urbana: University of Illinois Press, 1989. First published as a special issue of the *Journal of Aesthetic Education* 21, no. 3 (1987).

Smith, Ralph A. *The Sense of Art: A Study in Aesthetic Education*. New York: Routledge, 1989.

Smith, Ralph A. *Excellence II: The Continuing Quest in Art Education*. Reston, Va.: National Art Education Association, 1995.

Smith, Ralph A., and Ronald Berman, eds. *Public Policy and the Aesthetic Interest: Critical Essays in Defining Cultural and Educational Relations*. Urbana: University of Illinois Press, 1992.

Smith, Ralph A., and Alan Simpson, eds. *Aesthetics and Arts Education*. Urbana: University of Illinois Press, 1991. A volume in the series Disciplines in Art Education: Contexts of Understanding.

Southeast Center for Education in the Arts. *Discipline-Based Music Education: A Conceptual Framework for the Teaching of Music*. Chattanooga: Southeast Center for Education in the Arts, 1994.

Stake, Robert, Liora Bresler, and Linda Mabry. *Custom and Cherishing: The Arts in Elementary Schools*. Urbana: Council for Research in Music Education, University of Illinois at Urbana-Champaign, 1991.

Stastny, Kimm. *The Pursuit of Collaboration: Where Does It Lead?* ERIC Document Reproduction Service ED341634, 1990.

Williams, Harold M. *The Language of Civilization: The Vital Role of the Arts in Education*. Washington, D.C.: President's Committee on the Arts and Humanities, 1991.

Williams, Harold M. *Public Policy and Arts Education*. Santa Monica, Calif.: J. Paul Getty Trust, 1993.

Wilson, Brent. *Art Education, Civilization, and the 21st Century: A Researcher's Reflections on the National Endowment for the Arts' Report to Congress*. Reston, Va.: National Art Education Association, 1988.

Wilson, Brent. *The Quiet Evolution: Changing the Face of Arts Education*. Los Angeles: Getty Education Institute for the Arts, 1997

Wolff, Theodore F., and George Geahigan. *Art Criticism and Education*. Urbana: University of Illinois Press, 1997. A volume in the series Disciplines in Art Education: Contexts of Understanding.

Zurmuehlen, Marilyn. *Studio Art: Praxis, Symbol, Presence*. Reston, Va.: National Art Education Association, 1990.

Reports and Proceedings

Amburgy, Patricia M., and others, eds. *The History of Art Education: Proceedings from the Second Penn State Conference, 1989*. Reston, Va.: National Art Education Association, 1992.

Broudy, Harry S., ed. *Report on the Aesthetic Education Project*. ERIC Document Reproduction Service ED224015, 1982.

Eisner, Elliot W., and Stephen M. Dobbs. *The Uncertain Profession: Observations on the State of Museum Education in Twenty American Museums*. Los Angeles: Getty Center for Education in the Arts, 1986.

Getty Center for Education in the Arts. *Issues in Discipline-Based Art Education: Strengthening the Stance, Extending the Horizons.* Seminar Proceedings. Los Angeles: Getty Center for Education in the Arts, 1987.

Getty Center for Education in the Arts. *Discipline-Based Art Education: What Forms Will It Take?* Proceedings of the First National Invitational Conference, 1987. Santa Monica, Calif.: Getty Center for Education in the Arts, 1988.

Getty Center for Education in the Arts. *The Preservice Challenge: Discipline-Based Art Education and Recent Reports on Higher Education.* Los Angeles: Getty Center for Education in the Arts, 1988.

Getty Center for Education in the Arts. *Education in Art: Future Building.* Proceedings of the Second National Invitational Conference, 1989. Los Angeles: Getty Center for Education in the Arts, 1989.

Getty Center for Education in the Arts. *From Snowbird I to Snowbird II: Final Report of the Getty Center's Preservice Education Project.* Los Angeles: Getty Center for Education in the Arts, 1990.

Getty Center for Education in the Arts. *Inheriting the Theory: New Voices and Multiple Perspectives on DBAE.* Seminar Proceedings. Los Angeles: Getty Center for Education in the Arts, 1990.

Getty Center for Education in the Arts. *Future Tense: Arts Education Technology.* Proceedings of the Third National Invitational Conference. Los Angeles: Getty Center for Education in the Arts, 1991.

Getty Center for Education in the Arts. *Insights: Museums, Visitors, Attitudes, Expectations: A Focus Group Experiment.* Los Angeles: Getty Center for Education in the Arts, 1991.

Getty Center for Education in the Arts. *Discipline-Based Art Education and Cultural Diversity.* Seminar Proceedings. Santa Monica, Calif.: Getty Center for Education in the Arts, 1993.

Getty Center for Education in the Arts. *Perspectives on Education Reform: Arts Education as Catalyst.* Proceedings of the Fourth National Invitational Conference, 1993. Santa Monica, Calif.: J. Paul Getty Trust, 1994.

Kern, Evan J., ed. *Collected Papers: Pennsylvania's Symposium on Art Education, Aesthetics, and Criticism, 1986.* Harrisburg: Pennsylvania Department of Education, n.d.

National Endowment for the Arts. *Toward Civilization: A Report on Arts Education.* Washington, D.C.: Government Printing Office, 1988.

RAND Corporation. *Art History, Art Criticism, and Art Production: An Examination of Art Education in Selected School Districts.* 3 vols. Santa Monica, Calif.: RAND Corporation, 1984.

Schwartz, Katherine A. *Alaska Center for Excellence in Art Education: Improving Visual Art Education in Alaska, 1991–1996.* Soldotna, Alaska: Kenai Peninsula College, 1996.

Articles

Addiss, Stephen. "How Art Historians Work." In *Art History and Education,* by Stephen Addiss and Mary Erickson, 72–95. Urbana: University of Illinois Press, 1993.

Admur, David. "Arts in Cultural Context: A Curriculum Inregrating Discipline-Based Art Education with Other Humanities Subjects at the Secondary Level." *Art Education* 46, no. 3 (1993): 12–19.

Anderson, Albert A. "Issues in Art Education: Discipline-Based Art Education." *American Craft* 52, no. 2 (1992): 68–69. Followed by Joyce Tognini and Colleen Fink, "Viewpoints," 70–81, and "Readings," 81.

Anderson, Frances E. "Electronic Media, Videodisc Technology, and the Visual Arts." *Studies in Art Education* 26, no. 4 (1985): 224–31.

Anderson, Jim, and Brent Wilson. "Professional Development and Change Communities." *Music Educators Journal* 83, no. 2 (1996): 38–42, 50.

Anderson, Kent. "Words and Deeds: Grading the Getty." *Journal of Wisconsin Art Education* 1 (1987): 3–10.

Anderson, Tom. "A Structure for Pedagogical Art Criticism." *Studies in Art Education* 30, no. 1 (1988):28-38.

Anderson, Tom. "Attaining Critical Appreciation through Art." *Studies in Art Education* 31, no. 3 (1990):132-40.

Anderson, Tom. "The Content of Art Criticism." *Art Education* 44, no. 1 (1991):16-24.

Anderson, Tom. "Defining and Structuring Art Criticism for Education." *Studies in Art Education* 34, no. 4 (1993):199-208.

Asmus, Edward, and Paul Haack. "Defining New Teaching Roles." *Music Educators Journal* 83, no. 2 (1996):27-32.

Barrett, Terry. "Criticizing Art with Children." In *Art Education: Elementary*, ed. Andra Johnson, 115-29. Reston, Va.: National Art Education Association, 1992.

Barrett, Terry. "Critics on Criticism." *Journal of Aesthetic Education* 28, no. 2 (1994):71-82.

Battin, Margaret P. "Cases for Kids: Using Puzzles to Teach Aesthetics to Children." *Journal of Aesthetic Education* 28, no. 3 (1994):98-104. Also in *Aesthetics for Young People*, ed. Ronald Moore, 89-104. Reston, Va.: National Art Education Association, 1994.

Bennett, William J. "Address to the Getty Center Conference on Art Education." In *Discipline-Based Art Education: What Forms Will It Take?* 32-43. Santa Monica, Calif.: Getty Center for Education in the Arts, 1988.

Bolin, Frances S. "The Interrelationship between Preservice and Inservice Education for Art Teachers and Specialists." In *The Preservice Challenge: Discipline-Based Art Education and Recent Reports on Higher Education*, 201-12. Los Angeles: Getty Center for Education in the Arts, 1988.

Boyer, Barbara. "DBAE and CLAE: Relevance for Minority and Multicultural Students." *Journal of Social Theory in Art Education* 9 (1989):58-63.

Boyer, Ernest L. "The Arts, Language, and Schools." In *Discipline-Based Art Education: What Forms Will It Take?* 46-51. Santa Monica, Calif.: Getty Center for Education in the Arts, 1988.

Brademas, John. "The Arts and Their Teaching: Prospects and Problems." In *Education in Art: Future Building*, 10-21. Los Angeles: Getty Center for Education in the Arts, 1989.

Brewer, Thomas M. "An Examination of Two Approaches to Ceramic Instruction in Elementary Education." *Studies in Art Education* 32, no. 4 (1991):196-206.

Brickell, Edward E., Nancy Tondre Jones, and Stephena H. Runyan. "An Art Curriculum for All Students." *Educational Leadership* 45, no. 4 (1988):15-16.

Broudy, Harry S. "Theory and Practice in Aesthetic Education." *Studies in Art Education* 28, no. 4 (1987):198-205.

Broudy, Harry S. "Art as General Education." *Alaska Journal of Art* 1 (1989):4-9.

Burton, Judith M. "Once More with Feeling: The Discipline of Art/the Art of Discipline." In *Discipline in Art: An Interdisciplinary Symposium*, ed. Thomas Ewens, 89-114. Providence: Rhode Island School of Design, 1986.

Burton, Judith. "Aesthetics in Art Education: Meaning and Value in Practice." In *Beyond DBAE: The Case for Multiple Visions in Art Education*, ed. Judith Burton, Arlene Lederman, and Peter London, 42-63. North Dartmouth: Art Education Department, Southeastern Massachusetts University, 1988.

Burton, Judith M. "The Arts in School Reform: Other Conversations." *Teachers College Record* 95, no. 4 (1994):477-93.

Carrier, David. "Teaching the New Art History." In *The History of Art Education: Proceedings from the Second Penn State Conference 1989*, ed. Patricia M. Amburgy and others, 28-36. Reston, Va.: National Art Education Association, 1992.

Chalmers, F. Graeme. "Beyond Current Conceptions of Discipline-Based Art Education." *Art Education* 40, no. 5 (1987): 58–61.

Clark, Gilbert A., Michael D. Day, and W. Dwaine Greer. "Discipline-Based Art Education: Becoming Students of Art." *Journal of Aesthetic Education* 21, no. 2 (1987): 129–93. Also in *Discipline-Based Art Education: Origins, Meaning, Development*, ed. Ralph A. Smith, 129–93. Urbana: University of Illinois Press, 1989. Excerpt reprinted in *Aesthetics and Arts Education*, ed. Ralph A. Smith and Alan Simpson, 236–44. Urbana: University of Illinois Press, 1991.

Cohen, Kathleen. "Implications of Discipline-Based Art Education for Preservice Art Education." In *The Preservice Challenge: Discipline-Based Art Education and Recent Reports on Higher Education*, 85–89. Los Angeles: Getty Center for Education in the Arts, 1988.

Collins, Bradford R. "What Is Art History?" *Art Education* 44, no. 1 (1991): 53–59.

Collins, Georgia, and Renee Sandell. "Informing the Promise of DBAE: Remember the Women, Children, and Other Folk." *Journal of Multi-cultural and Cross-cultural Research in Art Education* 6, no. 1 (1988): 55–63.

Copeland, Betty D. "Art and Aesthetic Education Learning Packages." *Art Education* 36, no. 3 (1983): 32–35.

Covey, Preston K. "Art or Forgery: The Strange Case of Han Van Meegeren: A Videodisc for Aesthetics and Art History." *Journal of Computing in Higher Education* 2, no. 1 (1990): 3–31.

Cowan, Marilee Mansfield, and Faith M. Clover. "Enhancement of Self-Concept through Discipline-Based Art Education." *Art Education* 44, no. 2 (1991): 38–45.

Crawford, Donald W. "Aesthetics and Discipline-Based Art Education." *Journal of Aesthetic Education* 21, no. 2 (1987): 227–39. Reprinted as "The Questions of Aesthetics," in *Aesthetics and Arts Education*, ed. Ralph A. Smith and Alan Simpson, 18–31. Urbana: University of Illinois Press, 1991.

Csikszentmihalyi, Mihaly. "Art and the Quality of Life." In *Inheriting the Theory: New Voices and Multiple Perspectives*, 57–58. Los Angeles: Getty Center for Education in the Arts, 1990. Seminar summary of remarks.

Csikszentmihalyi, Mihaly, and Ulrich Schiefele. "Art Education, Human Development, and the Quality of Experience." In *The Arts, Education, and Aesthetic Knowing*. Ninety-first Yearbook of the National Society for the Study of Education, Part II, ed. Bennett Reimer and Ralph A. Smith, 169–91. Chicago: University of Chicago Press, 1992.

Davis, Jessica, and Howard Gardner. "The Cognitive Revolution: Consequences for the Understanding and Education of the Child as Artist. In *The Arts, Education, and Aesthetic Knowing*. Ninety-first Yearbook of the National Society for the Study of Education, Part II, ed. Bennett Reimer and Ralph A. Smith, 92–123. Chicago: University of Chicago Press, 1992.

Day, Michael D. "Evaluating Student Achievement in Discipline-Based Art Programs." *Studies in Art Education* 26, no. 4 (1985): 232–40.

Day, Michael D. "Artist-Teacher: A Problematic Model for Art Education." *Journal of Aesthetic Education* 20, no. 4 (1986): 38–42.

Day, Michael D. "Discipline-Based Art Education in Secondary Classrooms." *Studies in Art Education* 28, no. 4 (1987): 234–42.

Day, Michael D. "The Characteristics, Benefits, and Problems Associated with Implementing DBAE." *NASSP Bulletin* 73, no. 517 (1989): 43–52.

Delacruz, Elizabeth Manley. "Multiculturalism and Art Education: Myths, Misconceptions, Misdirections." *Art Education* 48, no. 3 (1995): 57–61.

Delacruz, Elizabeth Manley, and Philip C. Dunn. "The Evolution of Discipline-Based Education." *Journal of Aesthetic Education* 30, no. 3 (1996): 67–82.

DiBlasio, Margaret Klempay. "Continuing the Translation: Further Delineation of the DBAE Format." *Studies in Art Education* 26, no. 4 (1985): 197–205.

DiBlasio, Margaret K. "Reflections on the Theory of Discipline-Based Art Education." *Studies in Art Education* 28, no. 4 (1987): 221-26.

Dobbs, Stephen Mark. "Discipline-Based Art Education: Moving from Theory to Practice." In *Education in Art: Future Building,* 70-79. Los Angeles: Getty Center for Education in the Arts, 1989.

Dobbs, Stephen Mark. "Discipline-Based Art Education: Some Questions and Answers." *NASSP Bulletin* 73, no. 517 (1989): 7-13.

Dobbs, Stephen Mark. "The Kettering Project: Memoir of a Paradigm." In *The History of Art Education: Proceedings from the Second Penn State Conference, 1989,* ed. Patricia M. Amburgy and others, 186-90. Reston, Va.: National Art Education Association, 1992.

Dobbs, Stephen Mark, and Elliot W. Eisner. "The Uncertain Profession: Educators in American Art Museums." *Journal of Aesthetic Education* 21, no. 4 (1987): 77-86.

Duke, Leilani Lattin. "The Getty Center for Education in the Arts." *Art Education* 36, no. 5 (1983): 5-8.

Duke, Leilani Lattin. "The Getty Center for Education in the Arts." *Phi Delta Kappan* 65, no. 9 (1984): 612-14.

Duke, Leilani Lattin. "The Role of Private Institutions in Art Education." *Journal of Aesthetic Education* 20, no. 4 (1986): 48-49.

Duke, Leilani Lattin. "The Getty Center for Education in the Arts and Discipline-Based Art Education." *Art Education* 41, no. 2 (1988): 7-12.

Duke, Leilani Lattin. "The Getty Center for Education in the Arts: A Progress Report." *Phi Delta Kappan* 69, no. 6 (1988): 443-46.

Duke, Leilani Lattin. "Mind Building and Arts Education." *Design for Arts in Education* 91, no. 3 (1990): 42-45.

Dunn, Phillip C. "Integrating the Arts: Renaissance and Reformation in Arts Education." *Arts Education Policy Review* 96, no. 4 (1995): 32-37.

Dunn, Philip C. "More Power: Integrated Interactive Technology and Art Education." *Art Education* 49, no. 6 (1996): 6-11.

Eadie, John J. "Implications of Discipline-Based Art Education for Preservice Art Education." In *The Preservice Challenge: Discipline-Based Art Education and Recent Reports on Higher Education,* 107-13. Los Angeles: Getty Center for Education in the Arts, 1988.

Eaton, Marcia Muelder. "Teaching through Puzzles in the Arts." In *The Arts, Education, and Aesthetic Knowing.* Ninety-first Yearbook of the National Society for the Study of Education, Part II, ed. Bennett Reimer and Ralph A. Smith, 151-68. Chicago: University of Chicago Press, 1992.

Eaton, Marcia Muelder. "Philosophical Aesthetics: A Way of Knowing and Its Limits." *Journal of Aesthetic Education* 28, no. 3 (1994): 19-31. Also in *Aesthetics for Young People,* ed. Ronald Moore, 19-31. Reston, Va.: National Art Education Association, 1994.

Ebitz, David. "The Uniqueness and Overlap among Art Production, Art History, Art Criticism, and Aesthetics: The View from Art History." In *The Preservice Challenge: Discipline-Based Art Education and Recent Reports on Higher Education,* 158-62. Los Angeles: Getty Center for Education in the Arts, 1988.

Ecker, David. "Aesthetics as Inquiry." In *Aesthetics Education: The Missing Dimension,* ed. Al Hurwitz, 23-41. Baltimore: Maryland Institute, College of Art, 1986.

Efland, Arthur D. "Curriculum Concepts of the Penn State Seminar: An Evaluation in Retrospect." *Studies in Art Education* 25, no. 4 (1984): 205-11.

Efland, Arthur. "Curricular Fictions and the Discipline Orientation in Art Education." *Journal of Aesthetic Education* 24, no. 3 (1990): 67-81.

Efland, Arthur. "History of Art Education as Criticism: On the Use of the Past." In *The History of Art Education: Proceedings from the Second Penn State Conference, 1989*, ed. Patricia M. Amburgy and others, 1-11. Reston, Va.: National Art Education Association, 1992.

Eisner, Elliot W. "Why Art in Education and Why Art Education?" In *Art History, Art Criticism, and Art Production: An Examination of Art Education in Selected School Districts. Vol. 1: Comparing the Process of Change across Districts*, vii-xii. Santa Monica, Calif.: RAND Corporation, 1984. Also in *Vol. 2: Case Studies of Seven Selected Sites*, ix-xii, 1984.

Eisner, Elliot W. "Discipline-Based Art Education: A Reply to Jackson." *Educational Researcher* 16, no. 9 (1987): 50-52.

Eisner, Elliot W. "Discipline-Based Art Education and Its Critics." *Art Education* 41, no. 6 (1988): 7-13.

Eisner, Elliot W. "The Principal's Role in Art Education." *Principal* 67, no. 3 (1988): 6-10.

Eisner, Elliot W. "Structure and Magic in Discipline-Based Art Education." In *Discipline-Based Art Education: What Forms Will It Take?* 6-21. Santa Monica, Calif.: Getty Center for Education in the Arts, 1988. Also in *Journal of Art and Design Education* 7, no. 2 (1988): 185-96.

Eisner, Elliot W. "Discipline-Based Art Education: Conceptions and Misconceptions." *Educational Theory* 40, no. 4 (1990): 423-30.

Eisner, Elliot W. "Implications of Artistic Intelligences for Education." In *Artistic Intelligences: Implications for Education*, ed. William J. Moody, 31-42. New York: Teachers College Press, 1990.

Eisner, Elliot W. "Evaluating the Teaching of Art." In *Evaluating and Assessing the Visual Arts in Education: International Perspectives*, ed. Doug Boughton, Elliot W. Eisner, and Johan Ligtvoet, 75-94. New York: Teachers College Press, 1996.

Eisner, Elliot W. "Overview of Evaluation and Assessment: Conceptions in Search of Practice." In *Evaluating and Assessing the Visual Arts in Education: International Perspectives*, 1-16. New York: Teachers College Press, 1996.

Emshwiller, Ed. "Inside, Outside Inside, Out." In *Inheriting the Theory: New Voices and Multiple Perspectives*, Seminar Proceedings, 3-4. Los Angeles: Getty Center for Education in the Arts, 1990. Seminar summary of remarks.

Erickson, Mary. "Styles of Historical Investigation." *Studies in Art Education* 26, no. 2 (1985): 121-24.

Erickson, Mary. "Balancing the Art Curriculum: Art Production, Art History, Art Criticism, and Aesthetics." In *Collected Papers, Pennsylvania's Symposium III on the Role of Studio in Art Education*, ed. Joseph B. DeAngelis, 117-23. Harrisburg: Pennsylvania Department of Education, 1989.

Erickson, Mary. "Curriculum: How Can Art History Be Organized and Taught?" In *Art History and Education*, by Stephen Addiss and Mary Erickson, 148-62. Urbana: University of Illinois Press, 1993.

Erickson, Mary. "A Sequence of Developing Art-Historical Understandings: Merging Teaching, Service, Research, and Curriculum Development." *Art Education* 48, no. 6 (1995): 23-24, 33-37.

Ewens, Thomas. "Beyond Getty: An Analysis of *Beyond Creating: The Place for Art in American Schools*." In *Discipline in Art Education: An Interdisciplinary Symposium*, ed. Thomas Ewens, 27-56. Providence: Rhode Island School of Design, 1986.

Ewens, Thomas. "Flawed Understandings: On Getty, Eisner, and DBAE." In *Beyond DBAE: The Case for Multiple Visions of Art Education*, ed. Judith Burton, Arlene Lederman, and Peter London, 5-25. North Dartmouth: Department of Art Education, Southeastern Massachusetts University, 1988.

Eyestone, June E. "A Study of Emergent Language Systems and Their Implications for Discipline-Based Art Education." *Visual Arts Research* 16, no. 1 (1990): 77-82.

Fehr, Dennis E. "From Theory to Practice: Applying the Historical Context Model of Art Criticism." *Art Education* 47, no. 5 (1994): 52-58.

Feinstein, Hermine. "The Art Response Guide: How to Read Art for Meaning, A Primer for Art Criticism." *Art Education* 42, no. 3 (1989): 42-53.

Feldman, David Henry. "Developmental Psychology and Art Education: Two Fields at the Crossroads." *Journal of Aesthetic Education* 21, no. 2 (1987): 243-59.

Ferreira, Thomas. "Problems and Issues in Teacher Credentialing." In *The Preservice Challenge: Discipline-Based Art Education and Recent Reports on Higher Education*, 184-87. Los Angeles: Getty Center for Education in the Arts, 1988.

Fleming, Paulette Spruill. "Pluralism and DBAE: Towards a Model for Cultural Art Education." *Journal of Multi-cultural and Cross-cultural Research in Art Education* 6, no. 1 (1988): 66-74.

Freedman, Kerry. "Recent Theoretical Shifts in the Field of Art History and Some Classroom Applications." *Art Education* 44, no. 6 (1991): 40-45.

Gaither, E. Barry. "Brunswick Stew." In *Inheriting the Theory: New Voices and Multiple Perspectives*, 27-29. Los Angeles: Getty Center for Education in the Arts, 1990. Seminar summary of remarks.

Garber, Elizabeth. "Implications of Feminist Art Criticism for Art Education." *Studies in Art Education* 32, no. 1 (1990): 17-26.

Gardner, Howard. "Artistic Intelligences." *Art Education* 36, no. 2 (1983): 47-49. Reprinted as "A Cognitive View of the Arts" in *Research Readings for Discipline-Based Art Education: A Journey beyond Creating*, ed. Stephen Mark Dobbs, 102-9. Reston, Va.: National Art Education Association, 1988.

Gardner, Howard. "Multiple Intelligences: Implications for Art and Creativity." In *Artistic Intelligences: Implications for Education*, ed. William J. Moody, 11-27. New York: Teachers College Press, 1990.

Gardner, Howard. "The Assessment of Student Learning in the Arts." In *Evaluating and Assessing the Visual Arts: International Perspectives*, ed. Doug Boughton, Elliot W. Eisner, and Johan Ligtvoet, 131-55. New York: Teachers College Press, 1996.

Geahigan, George. "Conceptualizing Art Criticism for Effective Practice." *Journal of Aesthetic Education* 30, no. 3 (1996): 23-42.

Geahigan, George. "Teaching Personal Response to Art." In *Art Criticism and Education*, by Theodore Wolff and George Geahigan, 200-224. Urbana: University of Illinois Press, 1997.

Gentile, J. Ronald, and Nancy C. Murnyack. "How Shall Students Be Graded in Discipline-Based Art Education?" *Art Education* 42, no. 6 (1989): 33-41.

Goldyne, Joseph. "The Uniqueness and Overlap among Art Production, Art History, Art Criticism, and Aesthetics: An Artist's Viewpoint." In *The Preservice Challenge: Discipline-Based Art Education and Recent Reports on Higher Education*, 163-69. Los Angeles: Getty Center for Education in the Arts, 1988.

Goodson, Carol Ann, and Ed Duling. "Integrating the Four Disciplines." *Music Educators Journal* 83, no. 2 (1996): 33-37.

Grant, Carl A. "So You Want to Infuse Mulicultural Education into Your Discipline? Case Study: Art Education." *Educational Forum* 57, no. 1 (1992): 18-28.

Greer, W. Dwaine. "A Structure of Discipline Concepts for DBAE." *Studies in Art Education* 28, no. 4 (1987): 227-33.

Greer, W. Dwaine. "Discipline-Based Art Education: Approaching Art as a Subject of Study." *Studies in Art Education* 25, no. 4 (1984): 212-18. Reprinted as "Art as a Serious Subject of Study" in *Research Readings for Discipline-Based Art Education: A Journey beyond Creating*, ed. Stephen Mark Dobbs, 112-24. Reston, Va.: National Art Education Association, 1988.

Greer, W. Dwaine. "Harry Broudy and Discipline-Based Art Education (DBAE)." *Journal of Aesthetic Education* 26, no. 4 (1992):49-60.

Greer, W. Dwaine. "Developments in Discipline-Based Art Education (DBAE): From Art Education toward Arts Education." *Studies in Art Education* 34, no. 2 (1993):91-101.

Greer, W. Dwaine, and Ralph Hoepfner. "Achievement Testing in the Visual Arts." *Design for Arts in Education* 88, no. 1 (1986):43-47.

Greer, W. Dwaine, and Jean C. Rush. "A Grand Experiment: The Getty Institute for Educators on the Visual Arts." *Art Education* 37, no. 1 (1985):24, 33-35.

Greer, W. Dwaine, and Ronald H. Silverman. "Making Art Important for Every Child." *Educational Leadership* 45, no. 4 (1987-88):10-14.

Gregory, Diane C. "Review of Elementary and Junior High School DBAE Instructional Resources." *Art Education* 42, no. 3 (1989):14-21.

Gregory, Diane C. "Art Education Reform and Interactive Integrated Media." *Art Education* 48, no. 3 (1995):6-16.

Hagaman, Sally. "Philosophical Aesthetics in the Art Class: A Look toward Implementation." *Art Education* 41, no. 3 (1988):18-22.

Hagaman, Sally. "Feminist Inquiry in Art History, Art Crtiticism, and Aesthetics: An Overview for Art Education." *Studies in Art Education* 32, no. 1 (1990):27-35.

Hamblen, Karen A. "An Analysis of Foundations of Art Criticism Instruction: Consequences of Theoretical and Research Deficits." *Arts and Learning Research* 4 (1986):85-91.

Hamblen, Karen A. "Testing in Art: A View from the Classroom." *Design for Arts in Education* 88, no. 1 (1986):12-16.

Hamblen, Karen A. "Three Areas of Concern for Art-Critical Instruction: Theoretical and Research Foundations, Sociological Relationships, and Teaching Methodologies." *Studies in Art Education* 27, no. 4 (1986):163-73.

Hamblen, Karen A. "An Examination of Discipline-Based Art Education Issues." *Studies in Art Education* 28, no. 2 (1987):68-78.

Hamblen, Karen A. "Approaches to Aesthetics in Art Education: A Critical Theory Perspective." *Studies in Art Education* 29, no. 2 (1988):81-90.

Hamblen, Karen A. "Cultural Literacy through Multiple DBAE Repertoires." *Journal of Multi-cultural and Cross-cultural Research in Art Education* 6, no. 1 (1988):88-98.

Hamblen, Karen A. "What Does DBAE Teach?" *Art Education* 41, no. 2 (1988):23-24, 33-35.

Hamblen, Karen A. "An Art Education Future in Two World Views." *Design for Arts in Education* 91, no. 3 (1990):27-33.

Hamblen, Karen A. "Developmental Models of Artistic Expression and Aesthetic Response: The Reproduction of Formal Schooling and Modernity." *Journal of Social Theory in Art Education* 13 (1993):37-56.

Hamblen, Karen A., and Camille Galanes. "Instructional Options for Aesthetics: Exploring the Possibilities." *Art Education* 44, no. 6 (1991):12-24.

Harris, Neil. "Conceiving the Art Museum: Some Historical Observations for the Getty Colloquium." In *Insights: Museums, Visitors, Attitudes, Expectations: A Focus Group Experiment,* 132-50. Los Angeles: Getty Center for Education in the Arts, 1991.

Hausman, Jerome. "Unity and Diversity in Art Education." In *Beyond DBAE: A Case for Multiple Visions of Art Education*, ed. Judith Burton, Arlene Lederman, and Peter London, 102-16. North Dartmouth: Art Education Department, Southeastern Massachusetts University, 1988.

Henley, David R. "Adapting Art Education for Exceptional Children." *School Arts* 96, no. 4 (1990):18-20.

Hewitt, Gloria J., and Jean C. Rush. "Finding Buried Treasures: Aesthetic Scanning with Children." *Art Education* 40, no. 1 (1987):40-43.

Hicks, Laurie E. "A Feminist Analysis of Empowerment and Community in Art Education." *Studies in Art Education* 32, no. 1 (1990):36-46.

Hobbs, Jack A. "Discipline-Based Art Education and an Enrichment of Feldman's Method of Criticism." *Texas Trends in Art Education* (Fall 1985):21-23.

Hobbs, Jack. "In Defense of a Theory of Art for Art Education." *Studies in Art Education* 34, no. 2 (1993):102-13.

Hodsoll, Frank. "Address to the Getty Center Conference on Art Education" In *Discipline-Based Art Education: What Forms Will It Take?* 104-17. Santa Monica, Calif.: Getty Center for Education in the Arts, 1988.

Housen, Abigail. "Three Methods of Understanding Museum Audiences." *Museum Studies Journal* 2, no. 4 (1987):41-49.

Hubbard, Guy. "Electronic Artstrands: Computer Delivery of Art Instruction." *Art Education* 48, no. 2 (1995):44-51.

Huber, Barbara Weir. "What Does Feminism Have to Offer DBAE? or So What if Little Red Riding Hood Puts aside Her Crayons to Deliver Groceries for Her Mother?" *Art Education* 40, no. 3 (1987): 36-41.

Hurwitz, Al. "DBAE Getty Style: On Art Making and Other Domains." In *Collected Papers: Pennsylvania's Symposium III on the Role of Studio in Art Education*, ed. Joseph B. DeAngelis, 133-39. Harrisburg: Pennsylvania Department of Education, 1989.

Jackson, Philip W. "Mainstreaming Art: An Essay on Discipline-Based Art Education." Review of *Beyond Creating: The Place for Art in America's Schools. Educational Researcher* 16, no. 6 (1987): 39-43.

Johnson, Margaret H., and Susan L. Cooper. "Developing a System for Assessing Written Art Criticism." *Art Education* 47, no. 5 (1994):21-26.

Johnson, Nancy R. "DBAE and Cultural Relationships." *Journal of Multi-cultural and Cross-cultural Research in Art Education* 6, no. 1 (1988):15-25.

Judson, Bay. "Teaching Aesthetics and Art Criticism to School Children in an Art Museum." *Museum Studies Journal* 2, no. 4 (1987).

Kaagan, Stephen. "Problems and Issues in Teacher Credentialing." In *The Preservice Challenge: Discipline-Based Art Education and Recent Reports on Higher Education*, 188-91. Los Angeles: Getty Center for Education in the Arts, 1988.

Kaelin, E. F. "The Construction of a Syllabus for Aesthetics in Art Education." *Art Education* 43, no. 2 (1990):22-24, 33-35.

Kaelin, E. F. "Why Teach Art in the Public Schools?" *Journal of Aesthetic Education* 20, no. 4 (1986): 64-71. Reprinted in *An Aesthetics for Art Educators*, 54-62. New York: Teachers College Press, 1989; and in *Aesthetics and Arts Education*, ed. Ralph A. Smith and Alan Simpson, 162-70. Urbana: University of Illinois Press, 1991.

Keens, William. "Future Tense/Future Perfect." *Art Education* 44, no. 5 (1991):22-24.

Keifer-Boyd, Karen T. "Interacting Hypermedia and the Internet with Critical Inquiry in the Arts: Preservice Training." *Art Education* 49, no. 6 (1996):33-41.

Kern, Evan J. "Antecedents of Discipline-Based Art Education: State Departments of Education Curriculum Documents." *Journal of Aesthetic Education* 21, no. 2 (1987): 35-56. Also in *Discipline-Based Art Education: Origins, Meaning, Development*, ed. Ralph A. Smith, 35-56. Urbana: University of Illinois Press, 1989.

Kindler, Anna. "Discipline-Based Art Education in Secondary Schools." *Journal of Art and Design Education* 11, no. 3 (1992):345-55.

Kleinbauer, W. Eugene. "Art History in Discipline-Based Art Education." *Journal of Aesthetic Education* 21, no. 2 (1987):205-15. Also in *Discipline-Based Art Education: Origins, Meaning, Development*, ed. Ralph A. Smith, 205-15. Urbana: University of Illinois Press, 1989.

Koroscik, Judith. "The Function of Domain-Specific Knowledge in Understanding Works of Art." In *Inheriting the Theory: New Voices and Multiple Perspectives*, 10-11. Los Angeles: Getty Center for Education in the Arts, 1990. Seminar summary of remarks.

Korzenik, Diana. "The Studio Artist." In *Coming Together Again: Art History, Art Criticism, Art Studio, Aesthetics*, ed. Eldon Katter, 17 pp. Kutztown, Pa.: College of Visual and Performing Arts, Kutztown University, 1984.

Korzenik, Diana. "Looking at Our Personal Histories and Educational Legacies." In *Art Making and Education*, by Maurice Brown and Diana Korzenik, 115-27. Urbana: University of Illinois Press, 1993.

Lai, Morris K., and Judy Shishido. "A Model for Evaluating Art Education Programs." *Arts and Learning Research* 5, no. 1 (1987):1-13.

Lanier, Vincent. "Aesthetics: Cornerstone of the Art Curriculum." In *Coming Together Again: Art History, Art Criticism, Art Studio, Aesthetics*, ed. Eldon Katter, 15 pp. Kutztown, Pa.: College of Visual and Performing Arts, Kutztown University, 1984.

Lanier, Vincent. "Discipline-Based Art Education: Three Issues." *Studies in Art Education* 26, no. 4 (1985):253-56.

Lankford, E. Louis. "A Phenomenological Methodology for Art Criticism." *Studies in Art Education* 25, no. 3 (1984):151-58.

Lankford, E. Louis. "Principles of Critical Dialogue." *Journal of Aesthetic Education* 20, no. 2 (1986): 59-63.

Lankford, E. Louis. "Preparation and Risk in Teaching Aesthetics." *Art Education* 43, no. 5 (1990): 50-56.

Levi, Albert William. "The Art Museum as an Agency of Culture." *Journal of Aesthetic Education* 19, no. 2 (1985):23-40.

Levi, Albert William. "The Creation of Art." In *Art Education: A Critical Necessity,* by Albert William Levi and Ralph A. Smith, 36-53. Urbana: University of Illinois Press, 1991.

Lovano-Kerr, Jessie. "Implications of DBAE for University Education of Teachers." *Studies in Art Education* 26, no. 4 (1985):216-23.

Lovano-Kerr, Jessie. "Cultural Pluralism and DBAE: An Issue (Fall, 1988) Revisited." *Journal of Multicultural and Cross-cultural Research in Art Education* 8, no. 1 (1990):61-71.

MacGregor, Ronald N. "An Outside View of Discipline-Based Education." *Studies in Art Education* 26, no. 4 (1985):241-46.

MacGregor, Ronald N. "Curriculum Reform: Some Past Practices and Current Implications." In *Issues in Discipline-Based Art Education: Strengthening the Stance, Extending the Horizons*. Seminar Proceedings, 117-26. Los Angeles: Getty Center for Education in the Arts, 1988. Response by D. Jack Davis.

MacGregor, Ronald N. "DBAE at the Secondary Level: Compounding Primary Gains." *NASSP Bulletin* 73, no. 517 (1989):23-29.

Maquet, Jacques. "Cross-Cultural Understanding of Visual Objects: Three Approaches." In *Inheriting the Theory: New Voices and Multiple Perspectives*, 23-24. Los Angeles: Getty Center for Education in the Arts, 1990. Seminar summary of remarks.

Marschalek, Douglas G. "A New Approach to Curriculum Development in Environmental Design." *Art Education* 42, no. 4 (1989):8-17.

Marschalek, Douglas. "The National Gallery of Art Laserdisk and Accompanying Database: A Means to Enhance Art Instruction." *Art Education* 44, no. 3 (1991):48-53.

Martin, Anna C. "Effects of Feedback on Preservice Teachers' Questioning Strategies." *Arts and Learning Research* 7, no. 1 (1989): 95-106.

Mason, Rachel, and Michael D. Rawding. "Aesthetics in DBAE: Its Relevance to Critical Studies." *Journal of Art and Design Education* 12, no. 3 (1993): 357-70.

McFee, June King. "An Analysis of the Goal, Structure, and Social Context of the 1965 Penn State Seminar and the 1983 Getty Institute for Educators on the Visual Arts." *Studies in Art Education* 25, no. 4 (1984): 176-81.

McFee, June. "Art and Society." In *Issues in Discipline-Based Art Education: Strengthening the Stance, Extending the Horizons*, 104-12. Los Angeles: Getty Center for Education in the Arts, 1988. Response by Stephen Mark Dobbs.

McGeary, Clyde. "Problems and Issues in Teacher Credentialing." In *The Preservice Challenge: Discipline-Based Art Education and Recent Reports on Higher Education*, 197-200. Los Angeles: Getty Center for Education in the Arts, 1988.

McMurrin, Lee R. "Principal's Role in Implementing Discipline-Based Art Education." *NASSP Bulletin* 73, no. 517 (1989): 31-34.

Meynell, Hugo A. "On the Nature of Art Criticism." *Journal of Aesthetic Education* 20, no. 4 (1986): 94-99.

Mittler, Gene. "Teaching Art Appreciation in the High School." *School Arts* 82, no. 3 (1982): 36-41.

Moore, Ronald. "Aesthetic Case Studies and Discipline-Based Art Education." *Journal of Aesthetic Education* 27, no. 3 (1993): 51-62.

Moore, Ronald. "Aesthetics for Young People: Problems and Prospects." *Journal of Aesthetic Education* 28, no. 3 (1994) 5-18. Also in *Aesthetics for Young People*, ed. Ronald Moore, 5-18. Reston, Va.: National Art Education Association, 1994.

Newman, Alan. "Report: What Did the Focus Groups Reveal?" In *Insights: Museums, Visitors, Attitudes, Expectations: A Focus Group Experiment*, 112-22. Los Angeles: Getty Center for Education in the Arts, 1991.

Olds, Clifton. "Teaching Art History in the Eighties: Some Problems and Frustrations." *Journal of Aesthetic Education* 20, no. 4 (1986): 99-103.

Ott, Robert William. "Art Education in Museums: Art Teachers as Pioneers in Museum Education." In *The History of Art Education: Proceedings from the Penn State Conference*, ed. Brent Wilson and Harlan Hoffa, 286-94. Reston, Va.: National Art Education Association, 1985.

Parsons, Michael J. "Cognition as Interpretation in Art Education." In *The Arts, Education, and Aesthetic Knowing*. Ninety-first Yearbook of the National Society for the Study of Education, Part II, ed. Bennett Reimer and Ralph A. Smith, 70-91. Chicago: University of Chicago Press, 1992.

Parsons, Michael J. "Can Children Do Aesthetics? A Developmental Account." *Journal of Aesthetic Education* 28, no. 3 (1994): 33-45.

Parsons, Michael J., and H. Gene Blocker. "Aesthetics, Art, and the Aesthetic Object." In *Aesthetics and Education*, by Michael J. Parsons and H. Gene Blocker, 5-33. Urbana: University of Illinois Press, 1993.

Parsons, Michael J., and H. Gene Blocker. "Aesthetics in the Classroom." In *Aesthetics and Education*, by Michael J. Parsons and H. Gene Blocker, 154-80. Urbana: University of Illinois Press, 1993.

Patchen, Jeffrey. "Overview of Discipline-Based Music Education." *Music Educators Journal* 83, no. 2 (1996): 19-26, 44.

Payne, Joyce A. "Manuel Barkan's *Foundations of Art Education*: The Past Is Prologue." In *The History of Art Education: Proceedings from the Penn State Conference*, ed. Brent Wilson and Harlan Hoffa, 259-64. Reston, Va.: National Art Education Association, 1985.

Peterson, Linda. "The Interrelationship between Preservice and Inservice Education for Art Teachers and Specialists." In *The Preservice Challenge: Discipline-Based Art Education and Recent Reports on Higher Education*, 217-19. Los Angeles: Getty Center for Education in the Arts, 1988.

Pitman, Bonnie. "Taking a Closer Look: Evaluation in Art Museums." In *Evaluating and Assessing the Visual Arts in Education: International Perspectives*, ed. Doug Boughton, Elliot W. Eisner, and Johan Ligtvoet, 249-66. New York: Teachers College Press, 1996.

Porett, Thomas. "Computer Graphics Overview." In *Collected Papers: Pennsylvania's Symposium III on the Role of Studio in Art Education*, ed. Joseph B. DeAngelis, 45-50. Harrisburg: Pennsylvania Department of Education, 1989.

Posey, Elsa. "Discipline-Based Arts Education: Developing a Dance Curriculum." *Journal of Physical Education, Recreation, and Dance* 59, no. 9.(1988):61-63.

Redfern, H. B. "Philosophical Aesthetics and the Education of Teachers." *Journal of Aesthetic Education* 22, no. 2 (1988): 35-46.

Reimer, Bennett. "Would Discipline-Based Music Education Make Sense?" *Music Educators Journal* 77, no. 9 (1991):21-28.

Rentl, Victor. "Significance of Recent National Reports for Preservice Discipline-Based Art Education." In *The Preservice Challenge: Discipline-Based Art Education and Recent Reports on Higher Education*, 122-33. Los Angeles: Getty Center for Education in the Arts, 1988.

Rice, Danielle. "The Uses and Abuses of Art History." In *Collected Papers: Pennsylvania's Symposium II on Art Education and Art History*, ed. Joseph B. DeAngelis, 7-14. Harrisburg: Pennsylvania Department of Education, 1989.

Rice, Danielle. "The Art Idea in the Museum Setting." *Journal of Aesthetic Education* 25, no. 4 (1991):127-36.

Risatti, Howard. "Art Criticism in Discipline-Based Art Education." *Journal of Aesthetic Education* 21, no. 2 (1987):217-25. Also in *Discipline-Based Art Education: Origins, Meaning, Development*, ed. Ralph A. Smith, 217-25. Urbana: University of Illinois Presss, 1989.

Rubin, Blanche M. "Using the Naturalistic Evaluation Process to Assess the Impact of DBAE." *NASSP Bulletin* 73, no. 517 (1989):36-41.

Rush, Jean C. "Should Fine Arts Be Required for High School Graduation?" *NASSP Bulletin* 69, no. 478 (1985):49-53.

Rush, Jean C. "Discipline-Based Art Education: Pragmatic Priorities for Realistic Research." *Journal of the Institute of Art Education* (Australia) 10, no. 1 (1986):23-35.

Rush, Jean C. "Research, the River, and the Art Education Engineers." *Design for Arts in Education* 88, no. 5 (1987):21-26.

Rush, Jean C. "Coaching by Conceptual Focus: Problems, Solutions, and Tutored Images." *Studies in Art Education* 31, no. 1 (1989): 46-57.

Rush, Jean C. "Concept Consistency and Problem Solving: Tools to Evaluate Learning in Studio Art." In *Evaluating and Assessing the Visual Arts in Education: International Perspectives*, ed. Doug Boughton, Elliot W. Eisner, and Johan Ligtvoet, 42-53. New York: Teachers College Press, 1996.

Rush, Jean C., W. Dwaine Greer, and Hermine Feinstein. "The Getty Institute: Putting Educational Theory into Practice." *Journal of Aesthetic Education* 20, no. 1 (1986):85-95.

Russell, Robert L. "The Aesthetician as a Model in Learning about Art." *Studies in Art Education* 27, no. 4 (1986):186-97.

Russell, Robert L. "Children's Philosophical Inquiry into Defining Art: A Quasi-experimental Study of Aesthetics in the Elementary School." *Studies in Art Education* 29, no. 3 (1988):282-91.

Sandell, Renee. "The Liberating Relevance of Feminist Pedagogy." *Studies in Art Education* 32, no. 3 (1991):178-87.

Sandell, Renee, and Cherry Schroeder. "Talking about Art, from Past to Present, Here to There: Preservice Art Teachers Collaborate with a Museum." *Art Education* 47, no. 4 (1994): 18-24.

Sankowski, Edward. "Ethics, Art, and Museums." *Journal of Aesthetic Education* 26, no. 3 (1992): 1-15.

Schwartz, Katherine. "Improving Art Education in Alaska through Discipline-Based Art Education." *Alaska Journal of Art* 1 (1989): 16-21.

Sevigny, Maurice J. "Significance of Recent National Reports for Preservice Discipline-Based Art Education." In *The Preservice Challenge: Discipline-Based Art Education and Recent Reports on Higher Education*, 134-52. Los Angeles: Getty Center for Education in the Arts, 1988.

Sevigny, Maurice J. "Discipline-Based Art Education and Teacher Education." *Journal of Aesthetic Education* 21, no. 2 (1987): 95-126. Also in *Discipline-Based Art Education: Origins, Meaning, Development*, ed. Ralph A. Smith, 3-34. Urbana: University of Illinois Press, 1989.

Silverman, Ronald H. "The Egalitarianism of Discipline-Based Art Education." *Art Education* 41, no. 2 (1988): 13-18.

Silverman, Ronald. "A Rationale for Discipline-Based Art Education." *NASSP Bulletin* 73, no. 517 (1989): 16-22.

Silvers, Anita. "Implications of Discipline-Based Art Education for Preservice Education." In *The Preservice Challenge: Discipline-Based Art Education and Recent Reports on Higher Education*, 94-101. Los Angeles: Getty Center for Education in the Arts, 1988.

Silvers, Anita. "Vincent's Story: The Importance of Contextualism for Art Education." *Journal of Aesthetic Education* 28, no. 3 (1994): 47-62. Also in *Aesthetics for Young People*, ed. Ronald Moore, 47-62. Reston, Va.: National Art Education Association, 1994.

Simmons, Sherwin. "Art History and Art Criticism: Changing Voice(s) of Authority." *Controversies in Art and Culture* 3, no. 1 (1990): 54-63.

Smith, Ralph A. "The Changing Image of Art Education: Theoretical Antecedents of Discipline-Based Art Education." *Journal of Aesthetic Education* 21, no. 2 (1987): 3-34. Also in *Discipline-Based Art Education: Origins, Meaning, Development*, ed. Ralph A. Smith, 3-34. Urbana: University of Illinois Press, 1989.

Smith, Ralph A. "The New Pluralism and Discipline-Based Art Education." In *Inheriting the Theory: New Voices and Muliple Perspecctives*, 74-76. Los Angeles: Getty Center for Education in the Arts, 1990. Seminar summary of remarks.

Smith, Ralph A. "A Percipience Curriculum for Discipline-Based Art Education." In *Art Education: A Critical Necessity*, by Albert William Levi and Ralph A Smith, 186-207. Urbana: University of Illinois Press, 1991.

Smith, Ralph A. "Art and Its Place in the Curriculum." *School Administrator* 50, no. 5 (1993): 23-30.

Smith, Ralph A. "The Question of Multiculturalism." *Arts Education Policy Review* 94, no. 4 (1993): 2-18. Also in *General Knowledge and Arts Education: An Interpretation of E. D. Hirsch's Cultural Literacy*, 79-108. Urbana: University of Illinois Press, 1994; and as "Multiculturalism and Cultural Particularism" in *Excellence II: The Continuing Quest in Art Education*, 115-37. Reston, Va.: National Art Education Association, 1995.

Smith, Ralph A. "An Excellence Curriculum, K-12." In *Excellence II: The Continuing Quest in Art Education*, 161-81. Reston, Va.: National Art Education Association, 1995.

Smith-Shank, Deborah L. "Semiotic Pedagogy and Art Education." *Studies in Art Education* 36, no. 4 (1995): 233-41.

Soren, Barbara. "The Museum as Curricular Site." *Journal of Aesthetic Education* 26, no. 3 (1992): 91-101.

Sowell, Joanne E. "A Learning Cycle Approach to Art History in the Classroom." *Art Education* 46, no. 2 (1993): 19-24.

Spitz, Ellen Handler. "Aesthetics for Young People: Some Psychological Reflections." *Journal of Aesthetic Education* 28, no. 3 (1994):63-76.

Spratt, Frederick. "Art Production in Discipline-Based Art Education." *Journal of Aesthetic Education* 21, no. 2 (1987):197-204. Also in *Discipline-Based Art Education: Origins, Meaning, Development*, ed. Ralph A. Smith, 197-204. Urbana: University of Illinois Press, 1989.

Stankiewicz, Mary Ann. "Structures and Experience: Response from the Second Generation." In *Inheriting the Theory: New Voices and Multiple Perspectives*, 76-78. Los Angeles: Getty Center for Education in the Arts, 1990. Seminar summary of remarks.

Stastny, Kimm. "Ideal Instructional Competencies for High School Art Teachers." *Design for Arts in Education* 90, no. 1 (1988):40-43.

Stewart, Marilyn Galvin. "Aesthetics and the Art Curriculum." *Journal of Aesthetic Education* 28, no. 3 (1994):77-88.

Stinespring, John A. "Discipline-Based Art Education and Art Criticism." *Journal of Aesthetic Education* 26, no. 3 (1992):106-12.

Stinespring, John A., and Linda C. Kennedy. "Meeting the Need for Multiculturalism in the Art Classroom." *Clearing House* 68, no. 3 (1995): 139-45.

Storr, Annie V. F. "Shock of Tradition: Museum Education and Humanism's Moral Test of Artistic Experience." *Journal of Aesthetic Education* 28, no. 1 (1994):1-12.

Stout, Candance Jesse. "Critical Conversations about Art: A Description of Higher-Order Thinking Generated through the Study of Art Criticism." *Studies in Art Education* 36, no. 3 (1995):170-88.

Swanger, David. "Discipline-Based Art Education: Heat and Light." *Educational Theory* 40, no. 4 (1990):437-42.

Sylva, Ron. "Multidimensional Engagement with Art." ERIC Documentation Service ED341609, 1989.

Taunton, Martha. "Questioning Strategies to Encourage Young Children to Talk about Art." *Art Education* 36, no. 4 (1983):40-43.

Thompson, Kathleen. "Maintaining Artistic Integrity in an Interdisciplinary Setting." *Art Education* 48, no. 6 (1995):39-45.

Tollifson, Jerry. "A Balanced Comprehensive Art Curriculum Makes Sense." *Educational Leadership* 45, no. 4 (1988):18-22.

Tollifson, Jerry. "The Interrelationshp between Preservice and Inservice Education for Art Teachers and Specialists." In *The Preservice Challenge: Discipline-Based Art Education and Recent Reports on Higher Education*, 219-23. Los Angeles: Getty Center for Education in the Arts, 1988.

Troeger, Betty Jo. "Delineating a Model of a Knowledge Base for Art Teacher Education: A Response to NCATE." *Visual Arts Research* 16, no. 2 (1990): 31-35.

Vallance, Elizabeth. "Art Criticism as Subject Matter in Schools and Art Museums." *Journal of Aesthetic Education* 22, no. 4 (1988):69-81.

Vallance, Elizabeth. "Artistic Intelligences and General Education." In *Artistic Intelligences: Implications for Education*, ed. William J. Moody, 79-84. New York: Teachers College Press, 1990.

Vallance, Elizabeth. "Issues in Evaluating Museum Education Programs." In *Evaluating and Assessing the Visual Arts in Education: International Perspectives*, ed. Doug Boughton, Elliot W. Eisner, and Johan Ligtvoet, 222-36. New York: Teachers College Press, 1996.

Van de Pitte, M. M. "Discipline-Based Art Education and the New Aesthetics." *Journal of Aesthetic Education* 28, no. 2 (1994):1-14.

Walsh-Piper, Kathleen. "Museum Education and the Aesthetic Experience." *Journal of Aesthetic Education* 28, no. 3 (1994):105-15. Also in *Aesthetics for Young People*, ed. Ronald Moore, 105-15. Reston, Va.: National Art Education Association, 1995.

Williams, Patterson B. "Educational Excellence in Art Museums: An Agenda for Reform." *Journal of Aesthetic Education* 19, no. 2 (1985):105-23. Also an adapted version in *Museum Studies Journal* 2, no. 4 (1987):20-28.

Wilson, Brent. "Art Criticism in the Schools: Some Ridiculous Realities and Some Sublime Prospects." In *Pennsylvania's Symposium on Art Education, Aesthetics, and Art Criticism*, ed. Evan J. Kern, 53-69. Harrisburg: Pennsylvania State Department of Education, 1986. Reprinted as "Art Criticism as Writing as well as Talking" in *Research Readings for Discipline-Based Art Education: A Journey beyond Creating*, ed. Stephen Mark Dobbs, 134-46. Reston, Va.: National Art Education Association, 1988.

Wilson, Brent. "Name Brand, Generic Brand, and Popular Brands: The Boundaries of Discipline-Based Art Education." In *Issues in Discipline-Based Art Education: Strengthening the Stance, Extending the Horizons*, 131-45. Los Angeles: Getty Center for Education in the Arts, 1988.

Wilson, Brent. "Of Trivial Facts and Speculative Inquiry: Philosophical Quandaries about Teaching Art History in the Schools." In *Collected Papers: Pennsylvania's Symposium II on Art Education and Art History*, ed. Joseph B. DeAngelis, 125-34. Harrisburg: Pennsylvania Department of Education, 1989.

Wilson, Brent. "Studio-Based Scholarship: Making Art to Know Art." In *Collected Papers: Pennsylvania's Symposium III on the Role of Studio in Art Education*, ed. Joseph B. DeAngelis, 11-20. Harrisburg: Pennsylvania Department of Education, 1989.

Wilson, Brent. "Arts Standards and Fragmentation: A Strategy for Holistic Assessment." *Arts Education Policy Review* 98, no. 2 (1996):2-9.

Wilson, Marjorie. "Working Works of Art." In *Collected Papers: Pennsylvania's Symposium III on the Role of Studio in Art Education*, ed. Joseph B. DeAngelis, 147-54. Harrisburg: Pennsylvania Department of Education, 1989.

Wolcott, Anne G. "Whose Shoes Are They, Anyway? A Contemporary Approach to Interpretation." *Art Education* 47, no. 5 (1994):14-20.

Wolf, Dennie Palmer. "All the Pieces That Go into It: The Many Stances of Aesthetic Understanding." In *Aesthetics Education: The Missing Dimension*, ed. Al Hurwitz, 75-99. Baltimore: Maryland Institute College of Art, 1986.

Wolf, Dennie Palmer. "The Growth of Three Aesthetic Stances: What Developmental Psychology Suggests about Discipline-Based Art Education." In *Issues in Discipline-Based Art Education: Strengthening the Stance, Extending the Horizons*, 85-100. Los Angeles: Getty Center for Education in the Arts, 1988. Response by Enid Zimmerman.

Wolf, Dennie Palmer, and Mary Burger. "More than Minor Disturbances: The Place of the Arts in American Education." In *Public Money and the Muse: Essays on Government Funding of the Arts*, ed. Stephen Benedict, 118-52. New York: W. W. Norton, 1991.

Wolff, Theodore F. "The Values and Work of the Art Critic." In *Art Criticism and Education*, by Theodore F. Wolff and George Geahigan, 33-66. Urbana: University of Illinois Press, 1997.

Wongse-Sanit, Naree. "Inquiry-Based Teaching Using the World Wide Web." *Art Education* 50, no. 2 (1997):19-24.

Yenawine, Philip. "Objects, Ideas, and Aesthetics." In *Inheriting the Theory: New Voices and Multiple Perspectives*, 41-42. Los Angeles: Getty Center for Education in the Arts, 1990. Seminar summary of remarks.

Instructional Resources

Alexander, Kay. *Learning to Look and Create: The Spectra Program*. Menlo Park, Calif.: Dale Seymour, 1994. Text, slides, poster.

Alexander, Kay, and Michael Day, eds. *Discipline-Based Art Education: A Curriculum Sampler*. Los Angeles: Getty Center for Education in the Arts, 1991.

Art Forum: Professional Development Audiotapes. Tucson, Ariz.: CRiZMAC Art and Cultural Educational Materials, 1996. W. Dwaine Greer (*Introduction to DBAE*); Michael Day (*Art Production*); Terry Barrett (*Art Criticism*); Marilyn Stewart (*Aesthetics*); and Eldon Katter (*Assessment*).

Art Works 1–6. Austin, Tex.: Holt, Rinehart and Winston, 1989. Teachers' manuals, audiovisual materials, timelines, etc.

Barrett, Terry, ed. *Lessons for Teaching Art Criticism.* ERIC:ART. Bloomington: Social Studies Development Center, Indiana University, 1994.

Brommer, Gerald F. *Discovering Art History*, 3d ed. Worcester, Mass.: Davis Publications, 1997. Secondary grades. Students' and teachers' editions, reproductions, slides, and transparencies.

Clark, Gilbert, and Kevina Maher. *Contemporary Materials for Teaching New Aspects of Art Education.* ERIC:ART. Bloomington: Social Studies Development Center, Indiana University, 1992.

Coveny, Anna Marie, ed. *Directions: Addressing Art History, Aesthetics, and Art Criticism in Illinois Schools.* De Kalb: College of Education, Northern Illinois University, 1990.

DiBlasio, Margaret, and Raymond DiBlasio. *smART Curriculum: Sequentially Managed Art Curriculum, Grades 1 to 6.* 6 vols. St. Paul, Minn.: ARTWORLD Press, 1987. Vol. 1, 107 pp.; vol. 2, 125 pp.; vol. 3, 144 pp.; vol. 4, 125 pp.; vol. 5, 149 pp.; vol. 6, 169 pp.

Discover Art K–8 Program. Worcester, Mass.: Davis Publications. Cynthia Colbert and Martha Taunton, *Discover Art: Kindergarten* (1990); Laura H. Chapman, *Adventures in Art: 1–6* (1994); *A World of Images, 7* (1992); and *Art Images and Ideas, 8* (1992). Curriculum programs: texts, prints, audiovisual materials.

Erickson, Mary, ed. *Lessons about Art in History and History in Art.* Gilbert Clark, consulting editor. ERIC:ART. Bloomington: Social Studies Development Center, Indiana University, 1992.

Erickson, Mary, and Eldon Katter. *Artery* (1991); *Artifacts* (1994); *Philosophy of Art* (1996); and *Token Response* (1991). Tucson, Ariz.: CRiZMAC Art and Cultural Educational Materials. DBAE games.

Greer, W. Dwaine. *SWRL Elementary Art Program.* Bloomington, Ind.: Phi Delta Kappa, 1977–91. Teachers' guides and filmstrips.

Hobbs, Jack A., and Richard Salome. *The Visual Experience*, 2d ed. Worcester, Mass.: Davis Publications, 1995. Texts, prints, and audiovisual materials.

Hubbard, Guy. *Art in Action, 1–8.* San Diego: Coronado, 1986. Texts for teachers and students.

Hurwitz, Al, and Michael Day. *Children and Their Art: Methods for the Elementary School*, 6th ed. Fort Worth: Harcourt Brace and Company, 1995.

Katz, Elizabeth L., E. Louis Lankford, and Jan D. Plank. *Themes and Foundations of Art.* St. Paul, Minn.: West Publishing, 1995. A high school text.

Mack, Stevie. *Masterpack 4–8.* Tucson, Ariz.: CRiZMAC Art and Cultural Educational Materials, 1995. Text and videotape.

Mittler, Gene. *Art in Focus*, 3d ed. Westerville, Ohio: Glencoe, 1994. Ninth grade.

Mittler, Gene, and Rosalind Ragans. *Exploring Art.* Westerville, Ohio: Glencoe, 1992. Sixth grade.

Mittler, Gene, and Rosalind Ragans. *Understanding Art.* Westerville, Ohio: Glencoe, 1992. Seventh grade.

Ragans, Rosalind. *Arttalk*, 2d ed. Westerville, Ohio: Glencoe, 1995. Ninth grade.

Multicultural Art Print Series

African American Art: Teacher's Guide. MAPS I. Glenview, Ill.: Crystal Productions, 1996.

Arts of India: Teachers Guide. MAPS III. Glenview, Ill.: Crystal Productions, 1992. Text by Lisa Vihos. Discussion questions and activities by Kallene Champlin.

Mexican-American Art: Teachers Guide. MAPS II. Glenview, Ill.: Crystal Productions, 1992. Writer, Eldon Katter.

Pacific Asian Art: Teacher's Guide. MAPS I. Glenview, Ill.: Crystal Productions, 1991.

Selected American Indian Artifacts: Teachers Guide. MAPS II. Glenview, Ill.: Crystal Productions, 1992. Writer, Eldon Katter.

Women Artists of the Americas: Teachers Guide. MAPS III. Glenview, Ill.: Crystal Productions, 1994. Text by Barbara Moore and Barbara Matteo. Discussion questions by Kellene Champlin.

Videotapes

Getty Center for Education in the Arts. *The Role of Art in General Education*, by Harry S. Broudy. Santa Monica, Calif.: Getty Center for Education in the Arts, 1988. Produced by the Brigham Young University Motion Picture Studio. 30 minutes.

Getty Center for Education in the Arts. *Arts for Life*. Santa Monica, Calif.: Getty Center for Education in the Arts, 1990. Produced and directed by Multi-Media Presentations. 15 minutes.

Getty Center for Education in the Arts and The Discovery Channel. *The Imagination Machines*. Santa Monica, Calif.: Getty Center for Education in the Arts, 1991. Produced by The Discovery Channel. 60 minutes.

Getty Center for Education in the Arts and the National Parent Teachers Association. *Be Smart, Include Art: A Planning Kit for PTAs*. Chicago: National Parent Teachers Association, 1992. Booklet, brochures, newsletter, and a 10-minute videotape.

Getty Center for Education in the Arts, The Learning Channel, and the National Education Association. *The Art of Learning*. Santa Monica, Calif.: Getty Center for Education in the Arts, 1993. Produced by Weidener Productions, Inc., for The Learning Channel. 60 minutes.

Getty Center for Education in the Arts. *"Why Are the Arts Essential to Educational Reform?"* Santa Monica, Calif.: Getty Center for Education in the Arts, 1993. Remarks by Gordon M. Ambach and a Focus-Group Conversation. Produced by Pacific Visions Communications, Inc. 30 minutes.

Getty Center for Education in the Arts. *Art Education in Action: An All-Participants Day Video Teleconference*. Santa Monica, Calif.: Getty Center for Education in the Arts, 1994. Produced by Pacific Visions Communications, Inc. 1 hour 45 minutes.

Getty Center for Education in the Arts. *Art Education Is More Than Art Education*. Santa Monica, Calif.: Getty Center for Education in the Arts, 1994. Produced by Pacific Visions Communications, Inc. 10 minutes.

Getty Center for Education in the Arts. *Teaching in and through the Arts*. Santa Monica, Calif.: Getty Center for Education in the Arts, 1995. Co-production of The Learning Channel, the National Education Association, and The Getty Center for Education in the Arts. 30 minutes.

Getty Center for Education in the Arts. *Art Education in Action. 1. Aesthetics. 2. Integrating the Art Disciplines. 3. Making Art. 4. Art History and Criticism 5. School-Museum Collaboration*. Santa Monica, Calif.: Getty Center for Education in the Arts, 1995. Five kits, each containing a viewer's guide by Michael D. Day and a 40-minute tape. Produced by Pacific Visions Communications, Inc.

Dissertations

Ament, Elizabeth. "Implications of Feminist Aesthetics for Art Education. Ph.D. diss., The Ohio State University, 1995. Abstract in *Dissertation Abstracts International* 56 (1995): 2085A.

Baumgarner, Constance Marie. "Artists in the Classroom: An Analysis of the Arts in Education Program of the National Endowment for the Arts." Ph.D. diss., The Pennsylvania State University, 1993. Abstract in *Dissertation Abstracts International* 54 (1993): 1643A–1644A.

Craig, Jayne Ellen. "A Philosophical Perspective for Art Educational Curriculum." Ph.D. diss., Illinois State University, 1992. Abstract in *Dissertation Abstracts International* 53 (1993): 2212A.

Darnell, F. Stephen. "Art Education and Environment: Reading Nineteenth Century Landscape Representation as Cultural Code and Historical Text." Ph.D. diss., The Pennsylvania State University, 1996. Abstract in *Dissertation Abstracts International* 57 (1996): 1448A.

Delacruz, Elizabeth Manley. "A Conceptual Framework for Teaching Aesthetics to Elementary Students." Ph.D. diss., The Florida State University, 1988. Abstract in *Dissertation Abstracts International* 50 (1989): 333A.

Dunnahoo, Dan Eldred. "Content Analysis of Elementary Art Teacher Preparation Textbooks: A Study of the Status of Discipline-Based Art Education in Art Teacher Preparation Texts." Ed.D. diss., University of Georgia, 1992. Abstract in *Dissertation Abstracts International* 53 (1992): 1025A.

Galbraith, Lynn. "Merging the Research on Teaching with Art Content: A Qualitative Study of a Preservice Art Education Course for General Elementary Teachers." Ph.D. diss., 1988. The University of Nebraska, Lincoln, 1988. Abstract in *Dissertation Abstracts International* 50 (1989): 417A.

Gaughan, Jane Murphy. "One Hundred Years of Art Appreciation Education: A Cross Comparison of the Picture Study Movement with the Discipline-Based Art Education Movement." Ed.D. diss., University of Massachusetts, 1990. Abstract in *Dissertation Abstracts International* 51 (1990): 718A.

Gray, Sharon Reed. "The Effects of Modified Discipline-Based Art Instruction on Mainstreamed Students' Attitudes, Achievement, and Classroom Performance in a Public School System." Ed.D. diss., Brigham Young University, 1992. Abstract in *Dissertation Abstracts International* 53 (1992): 1770A.

Green, Gaye Leigh. "The Oval Lady: A Semiotic Approach to Art Interpretation in Art Education Applied to the Work of Leonora Carrington." Ph.D. diss., The Pennsylvania State University, 1994. Abstract in *Dissertation Abstracts International* 55 (1994): 1454A.

Harris, William Elgie. "A Qualitative Study of Elementary Teachers Implementing Multicultural Content with Discipline-Based Art Education." Ph.D. diss., The Ohio State University, 1996. Abstract in *Dissertation Abstracts International* 57 (1996): 555A.

Humpries, Holle Lynn. "An Exemplary Unit of Instruction Designed to Introduce Secondary Students to Instructional Content about Computer Art and Discipline-Based Art Education." Ph.D. diss., Texas Tech University, 1995. Abstract in *Dissertation Abstracts International* 56 (1995): 1630A.

James, Patricia Ann. "The Construction of Learning in a Sculpture Studio Classroom: An Ethographic Study." Ph.D. diss., University of Minnesota, 1994. Abstract in *Dissertation Abstracts International* 55 (1994): 779A.

Kalmite, Lelde Alida. "A Comparative Analysis of Conceptions of Art in Contemporary Studio Art and K-12 Art Education: World War II to Present." Ph.D. diss., University of Minnesota, 1995. Abstract in *Dissertation Abstracts International* 56 (1995): 1630A.

Kia, Ardeshir. "The Transition from Modernism to Postmodernism and Its Problematic Impact on Art Education Curriculum." Ph.D. diss., The University of Wisconsin-Madison, 1988. Abstract in *Dissertation Abstracts International* 50 (1989): 333A.

Lachapelle, Richard E. "Aesthetic Understanding as Informed Experience: Ten Informant-Made Videographic Accounts about the Process of Aesthetic Learning." Ph.D. diss., Concordia University, 1994. Abstract in *Dissertation Abstracts International* 56 (1996): 4255A-4256A.

Marché, Theresa Ann. "A History of Change in the Art Program of a Suburban Pennsylvania School District." Ph.D. diss., Indiana University, 1995. Abstract in *Dissertation Abstracts International* 56 (1995): 2087A.

Markey, Jill Reiling. "A Qualitative Exploration of Discipline-Based Art Education and the Ohio Partnership." Ph.D. diss., The Ohio State University, 1990. Abstract in *Dissertation Abstracts International* 51 (1990): 718A.

Matthews, Jonathan C. "Mindful Body, Embodied Mind." Ph.D. diss., Stanford University, 1994. Abstract in *Dissertation Abstracts International* 55 (1994): 425A–426A.

Myers, Sally Ann. "A Description and Analysis of Preconceptions about Art and Art Education Held by Preservice Elementary Education Students." Ph.D. diss., The University of Arizona, 1992. Abstract in *Dissertation Abstracts International* 53 (1993): 3780A.

Ndubuike, Darlington I. "Rituals of Identity: Examining the Cultural Context of the Art of the African Native with Implications for Multi-cultural and Cross-cultural Discipline-Based Art Education." Ed.D. diss., University of Houston, 1994. Abstract in *Dissertation Abstracts International* 56 (1995): 1801A.

Pankratz, David Barclay. "Multiculturalism and the Arts: An Analysis of Conceptual Foundations and Policy Issues." Ph.D. diss., The Ohio State University, 1992. Abstract in *Dissertation Abstracts International* 53 (1993): 2653A.

Sabol, Frank Robert. "A Critical Examination of Visual Arts Achievement Tests from State Departments of Education in the United States." Ph.D. diss., Indiana University, 1994. Abstract in *Dissertation Abstracts International* 56 (1995): 437A.

Schiller, Marjorie Ann. "An Interpretive Study of Teacher Change during Staff Development with Teachers of Special Education." Ph.D. diss., The University of Arizona, 1990. Abstract in *Dissertation Abstracts International* 51 (1990): 4088A.

Schwartz, Katherine Anne. "Educators' Perceptions of an Institutional Supervision System for Discipline-Based Art Education." Ph.D. diss., The University of Arizona, 1987. Abstract in *Dissertation Abstracts International* 48 (1987): 368A.

Shipps, Stephen William. "Last Impressions? Aesthetic Theory and Outcomes in 'Art 101.'" Ed.D. diss., Harvard University, 1994. Abstract in *Dissertation Abstracts International* 55 (1994): 450A.

Short, Georgianna. "Problems of Advanced Learning in the Visual Arts: The Role of Reductive Bias in Preservice Teachers' Understanding of Domain Knowledge." Ph.D. diss., The Ohio State University, 1995. Abstract in *Dissertation Abstracts International* 56 (1996): 3421A.

Sibbald, Mary Jo. "A Humanistic Approach to Discipline-Based Music Education." Ph.D. diss., University of Illinois at Urbana-Champaign, 1989. Abstract in *Dissertation Abstracts International* 50 (1989): 3883A.

Slavik, Susan Joyce. "An Examination of the Effects of Selected Disciplinary Art Teaching Strategies on the Cognitive Development of Selected Sixth-Grade Students." Ph.D. diss., The Florida State University, 1995. Abstract in *Dissertation Abstracts International* 56 (1996): 2975A.

Stewart, James Noble. "The Penn State Seminar in Art Education: An Oral History." Ph.D. diss., The Florida State University, 1986. Abstract in *Dissertation Abstracts International* 47 (1987): 4271A.

Supplee, Barbara. "Reflections on the Barnes Foundation's Aesthetic Theory, Philosophical Antecedents and 'Method' for Appreciation." Ph.D. diss., The Pennsylvania State University, 1995. Abstract in *Dissertation Abstracts International* 57 (1996): 75A.

Villeneuve, Pat. "Contending Art Education Paradigms and Professionalization." Ph.D. diss., The University of Arizona, 1992. Abstract in *Dissertation Abstracts International* 54 (1993): 407A.

Walsh, Dawna Marlyn Hamin. "A Discipline-Based Art Education Model for Criticism and Inquiry Directed to Non-Western Art." Ph.D. diss., Texas Tech University, 1992. Abstract in *Dissertation Abstracts International* 53 (1993): 4177A.

Williams, Betty Lou. "An Examination of Art Education Practices since 1984: In the Context of the Evolution of Art Museum Education in America." Ph.D. diss., The Florida State University, 1994. Abstract in *Dissertation Abstracts International* 55 (1994): 2688A.

Young, Ruth Whitelaw. "Art Education in Art Museums: Curriculum, Policy, and Culture." Ph.D. diss., University of Illinois at Urbana-Champaign, 1995. Abstract in *Dissertation Abstracts International* 56 (1996): 3422A.

Zimmerman, Jan Elfline. "An Analysis of University-Level General Education Courses in the Visual Arts (Art Curriculum)." Ed.D. diss., Illinois State University, 1992. Abstract in *Dissertation Abstracts International* 53 (1992): 1371A.

Advocacy

Arts Education Partnership Working Group. *The Power of the Arts to Transform Education*. Washington, D.C.: John F. Kennedy Center for the Performing Arts and J. Paul Getty Trust, 1993.

Getty Center for Education in the Arts. *Art Education in Action: An All-Participants Day Video Teleconference*. Los Angeles: Getty Center for Education in the Arts, 1994.

Getty Center for Education in the Arts. *Beyond the Three Rs: Student Achievement through the Arts*. Summary of the Fifth National Invitational Conference, 1995. Information insert in *Educational Leadership* 53, no. 2 (1995).

Getty Education Institute for the Arts and *Business Week*. *Educating for the Workplace through the Arts*. Information insert in *Business Week*, no. 3499 (28 October 1996).

Kaagan, Stephen S. *Aesthetic Persuasion: Pressing the Cause of Arts Education in American Schools*. Los Angeles: Getty Center for Education in the Arts, 1990.

Loyacono, Laura L. *Reinventing the Wheel: A Design for Student Achievement in the 21st Century*. Denver, Colo.: National Conference of State Legislatures, 1992.

National School Boards Association. *More Than Pumpkins in October: Visual Literacy in the 21st Century*. Alexandria, Va.: National School Boards Association, 1992. Fifteen-minute videotape also available.

Index

About the Author

Stephen Mark Dobbs is a native San Franciscan who was educated at Stanford University, completing fellowships in American History and psychology and a doctorate in education and the arts. As a professor of arts and humanities at San Francisco State University, Dobbs founded the InterArts Center and was assistant to the president of the university.

Dr. Dobbs has also been a visiting professor or scholar at Harvard, Stanford, University of Washington, and University of London. He has served as a program analyst with the JDR 3rd Fund in New York City and later served as senior program officer for the Getty Education Institute for the Arts.

In 1989 he was appointed CEO and executive director of the Koret Foundation, a San Francisco-based philanthropy. In 1991 he assumed responsibilities as president and CEO of the Marin Community Foundation, the third-largest community foundation in the United States.

Designer: Eileen Delson

Production Coordinators: Elizabeth Zozom, Amita Molloy

Typography: G & S Typesetting, Inc., Austin, Texas; Eileen Delson

Printing: Malloy Lithographing, Inc.

Photography Coordinator: Madeleine Coulombe

Copy Editor: Judy Selhorst

Indexer: Kathy Preciado

Managing Editor: Kathy Talley-Jones

Photography Credits